BOOK SOLD

MO LONGER R.H.P.L

		3						
								•.
								/

RICHMOND HILL PUBLIC LIBRARY

SEP 12 2000

CENTRAL BRANCH 884-9288

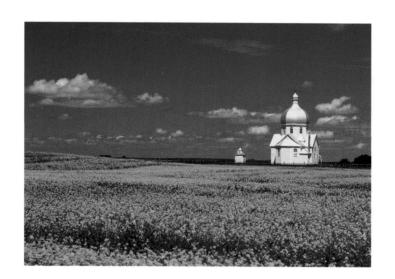

SASKATCHEWAN

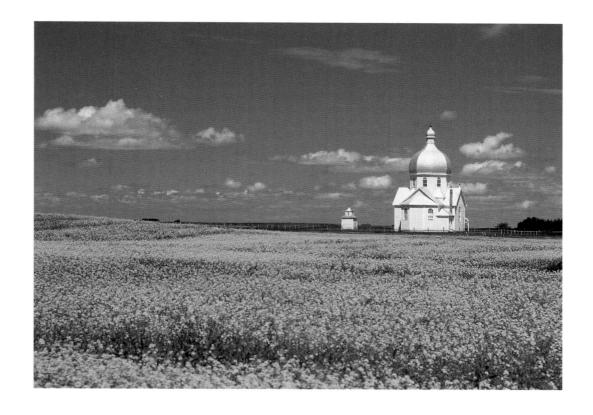

WHITECAP BOOKS
VANCOUVER / TORONTO / NEW YORK

Copyright © 2000 by Whitecap Books Ltd. Vancouver/Toronto/New York

All rights reserved. No part of this publication may be reproduced, stored in a retrieval system, or transmitted in any form or by any means, electronic, mechanical, photocopying, recording or otherwise, without prior written permission of the publisher.

The information in this book is true and complete to the best of our knowledge. All recommendations are made without guarantee on the part of the author or Whitecap Books Ltd. The author and publisher disclaim any liability in connection with the use of this information. For additional information please contact Whitecap Books Ltd., 351 Lynn Avenue, North Vancouver, BC V7J 2C4.

Text by Tanya Lloyd
Edited by Elaine Jones
Photo editing by Tanya Lloyd
Proofread by Kathy Evans
Cover and interior design by Steve Penner
Printed and bound in Canada

SEP 12 2000

Canadian Cataloguing in Publication Data

Lloyd, Tanya, 1973– Saskatchewan

ISBN 1-55285-078-1

1. Saskatchewan—Pictorial works. I. Title.

FC3512.L56 2000

971.24'03'0222

C00-910058-X

F1071.8.L56 2000

The publisher acknowledges the support of the Canada Council and the Cultural Services Branch of the Government of British Columbia in making this publication possible. We acknowledge the financial support of the Government of Canada through the Book Publishing Industry Development Program for our publishing activities.

For more information on the Canada Series and other Whitecap Books titles, please visit our web site at www.whitecap.ca.

National Park. In the sky, light cirrus clouds draw wispy paths to the horizon. A rattlesnake basks in the hot sun and a coyote slinks in the shadows of the few sparse trees. The vibrant yellow blooms of prickly pear cactus scent the air. Could this desert-like landscape be Saskatchewan? Could the waving wheat fields pictured on calendar covers, and the W. O. Mitchell stories of rural life have given us a limited view of the province?

Well, it's true that there are vast tracts of agricultural land in Saskatchewan. Farms produce more than 13 million tonnes (14 million tons) of wheat each year along with 5 million tonnes (5.5) of barley, 1.6 million tonnes (1.8) of oats, and 185,000 tonnes (204,000) of rye. Even the less important crops are harvested on an almost unbelievable scale. If no peas were exported from the province, there would be 1.7 tonnes (1.9 tons) of peas for each resident.

But Saskatchewan is not all barns and fencelines, waving crops and picturesque grain elevators. In fact, more than two-thirds of the population lives in urban areas. Regina residents enjoy festivals and sports in Wascana Centre, one of the largest urban parks in North America, while in Saskatoon, University of Saskatchewan students or local businesspeople relish the bustling atmosphere of downtown, an array of cultural performances, and an unmatched setting along the shores of the South Saskatchewan River. Ten other cities, from Moose Jaw to Prince Albert, offer events and attractions to tempt any visitor.

And outside the city borders, outdoors enthusiasts will find far more than wheat fields. The province's protected areas include unique landscapes like those of Grasslands National Park, wilderness preserves where large tracts of pristine land provide habitat for wildlife, and parks of historical and cultural significance. From parks to cosmopolitan cities, canoe routes to theatre performances, Saskatchewan offers much more than meets the eye.

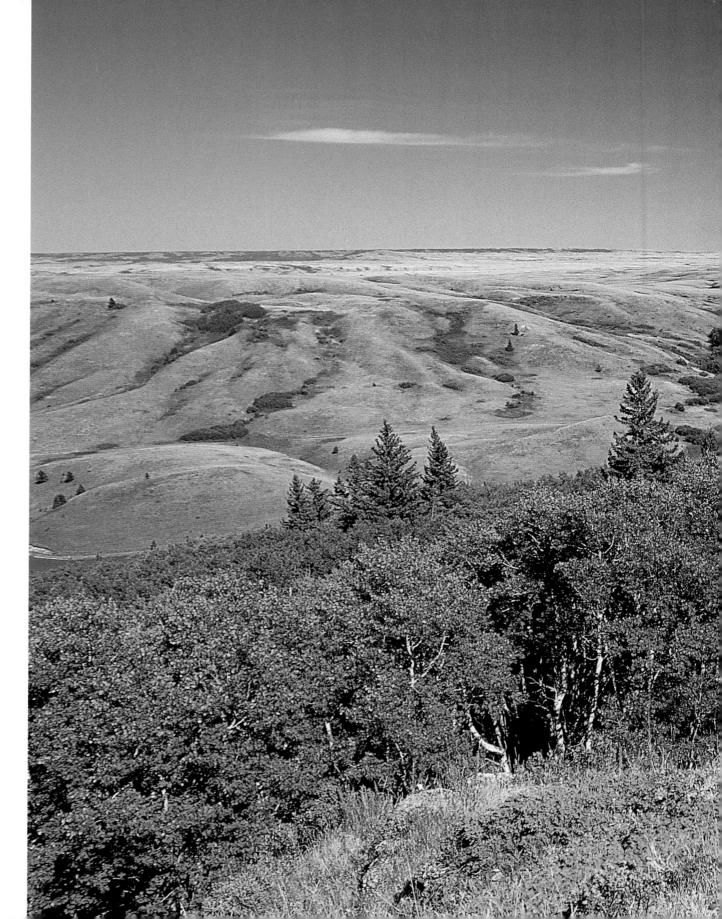

Rising 1,436 metres (4,711 feet) above sea level, the Cypress Hills are the highest land between Labrador and the Rocky Mountains. The area was named by fur traders, who mistakenly identified the plentiful lodgepole pines as cypress trees.

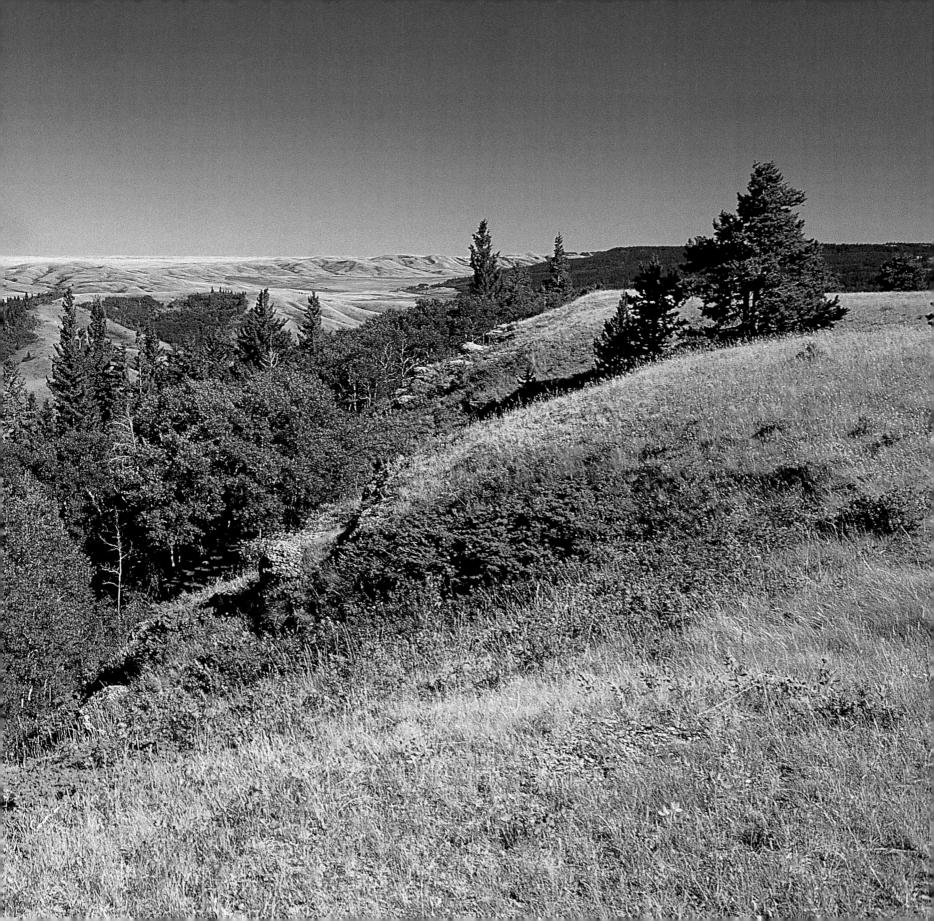

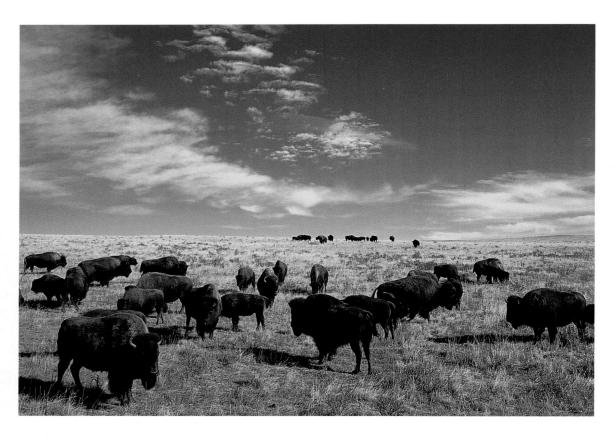

Herds of bison once again roam the grasslands, after a close brush with extinction in the late 1800s. One of the main threats to the animal today is the dwindling prairie, as agriculture and urban areas envelop more land.

Cypress Hills Interprovincial Park spans the Alberta-Saskatchewan border, offering visitors canoeing, swimming, hiking, camping, and picnicking spots.

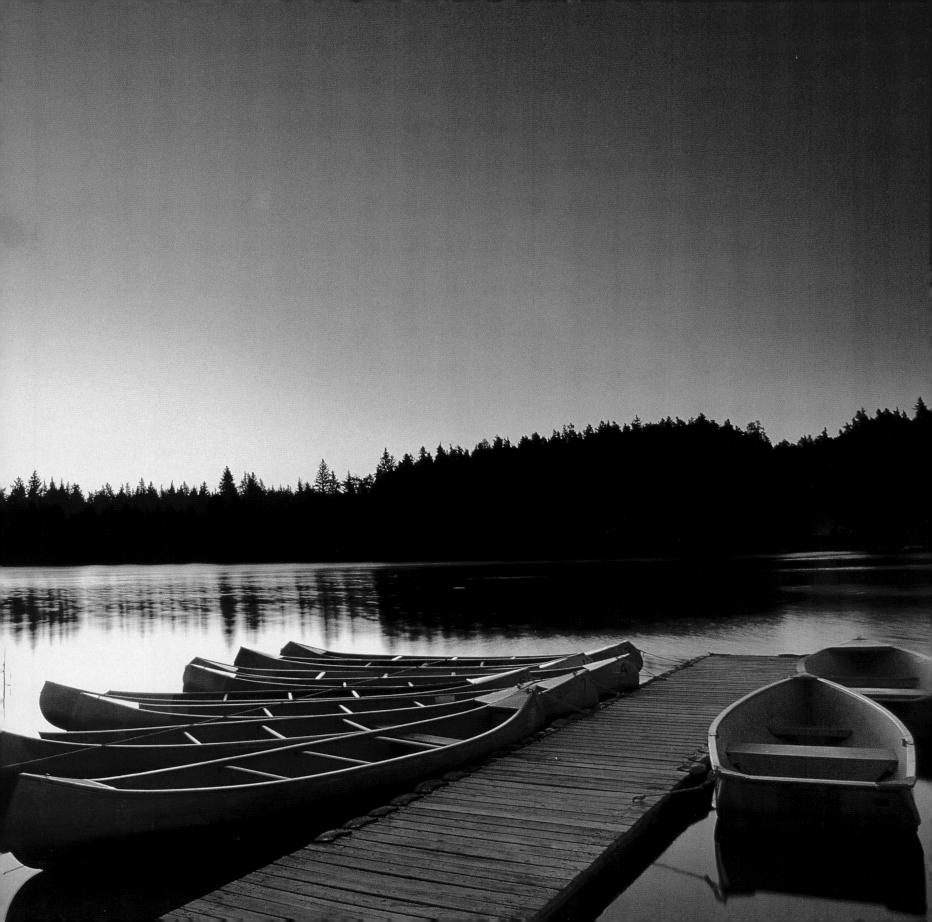

Ranching is the staple of the economy around the town of Maple Creek. Roping clubs, 4-H clubs, five summer rodeos, and an annual Cowboy Poetry Reading have earned the community the nickname "Old Cowtown."

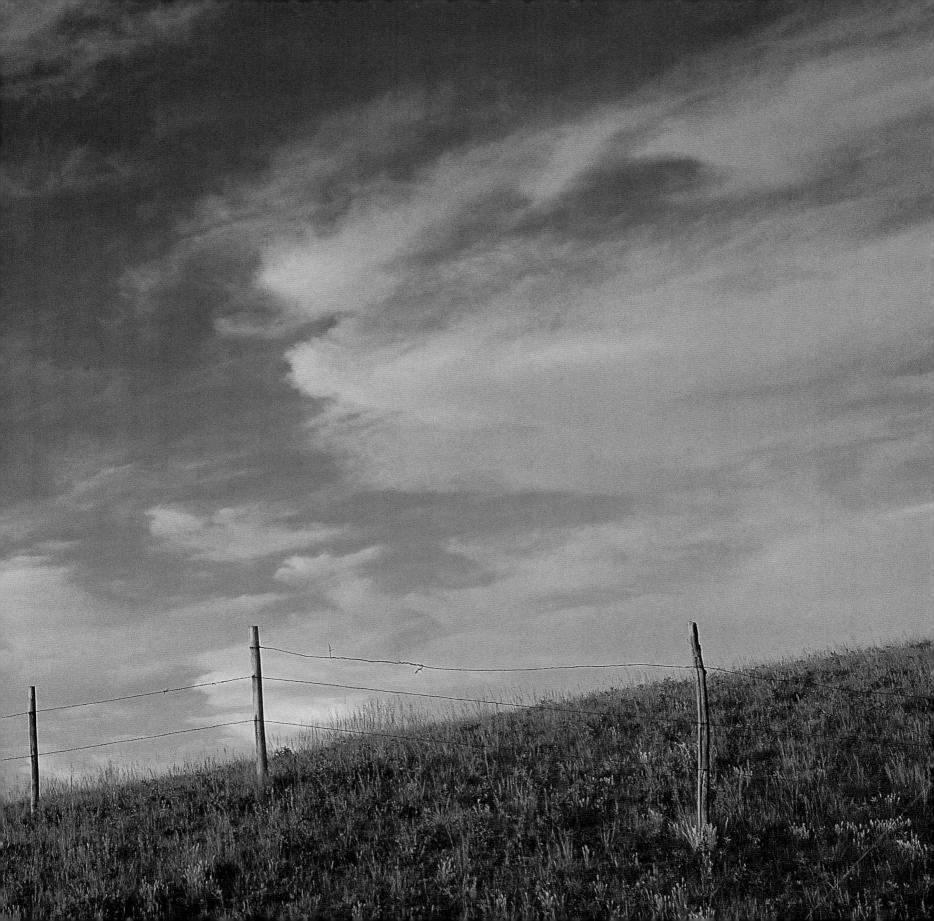

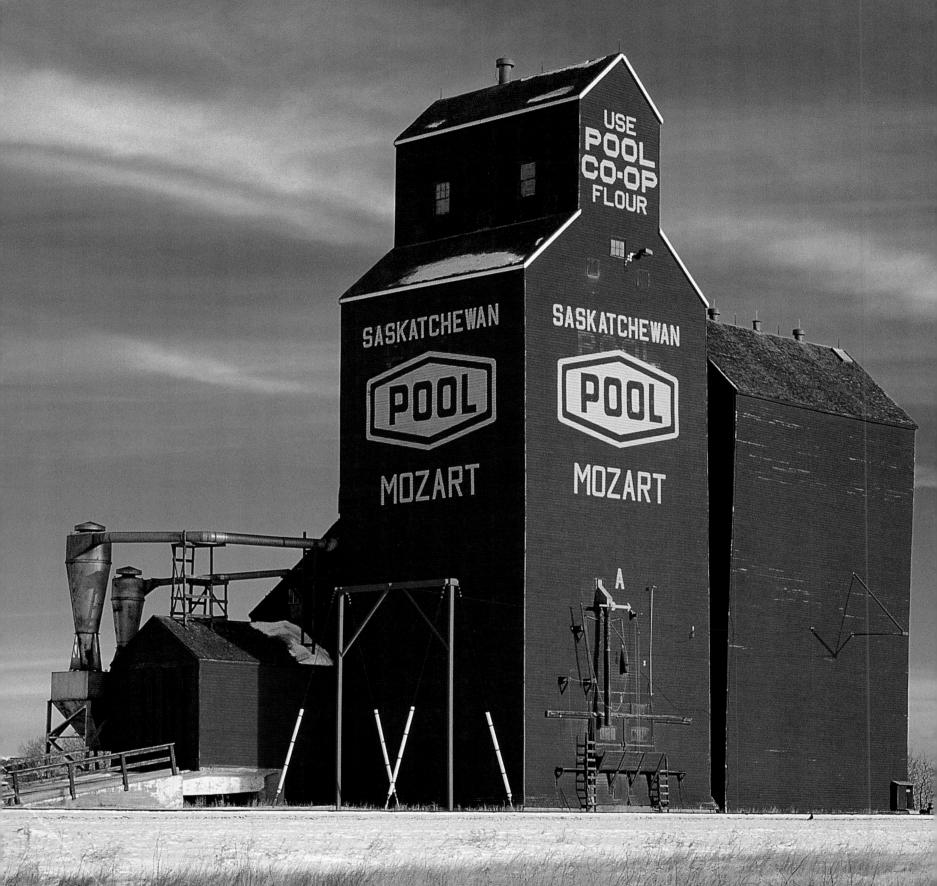

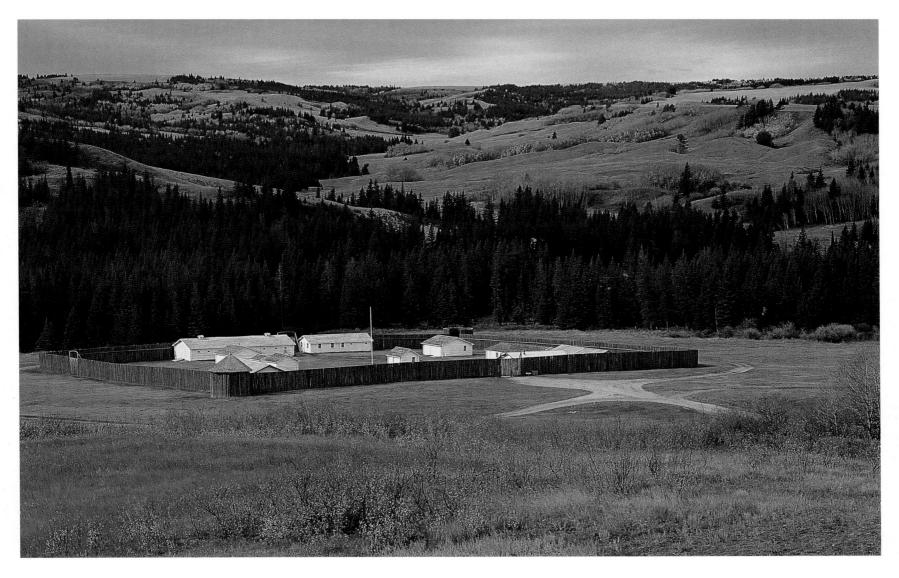

When First Nations people were slaughtered in 1873 by whisky traders and wolf hunters in the infamous Cypress Hills Massacre, the North West Mounted Police responded. From Fort Walsh—now a national historic site—they strove to end the whisky trade and impose order on the area.

Grain elevators are one of the most recognizable symbols of the Canadian Prairies. When King George VI and Queen Elizabeth visited Canada in 1939, they stopped for a tour of a Saskatchewan Wheat Pool elevator.

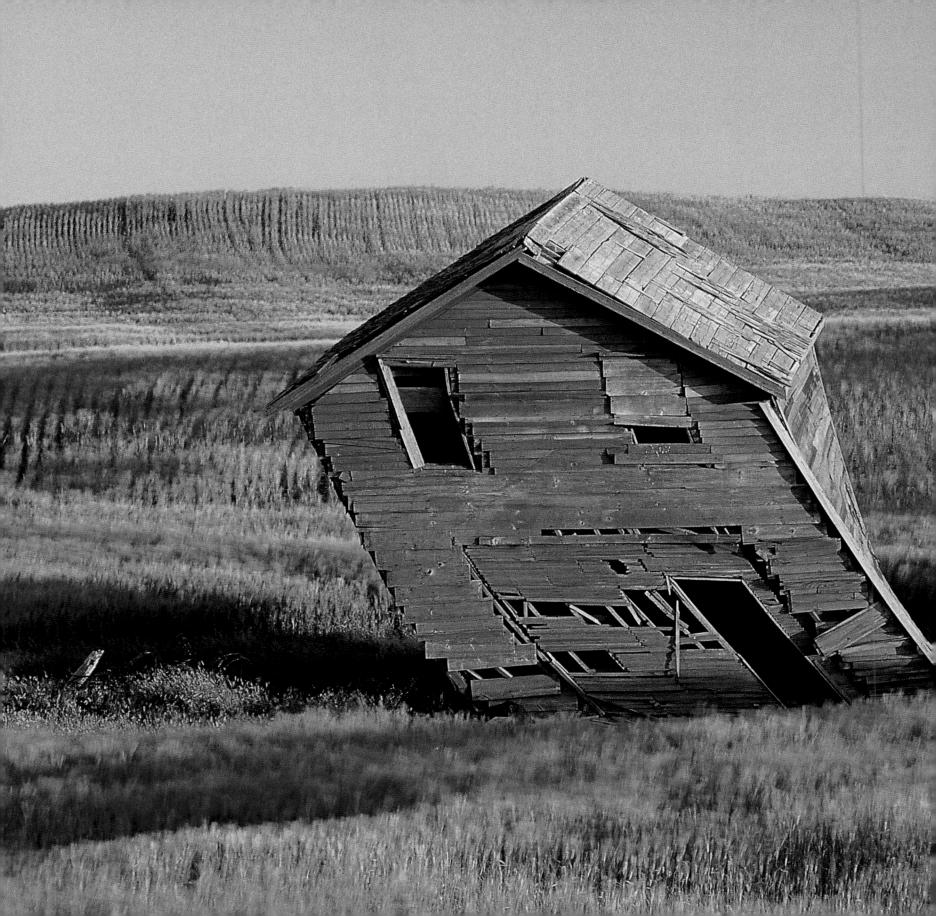

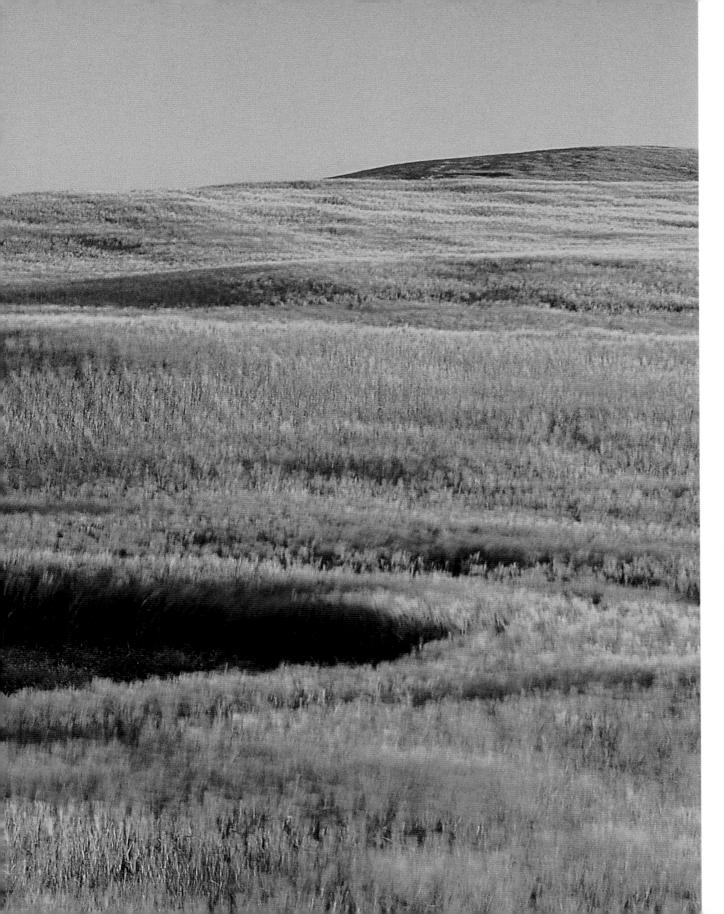

Saskatchewan is the only province in Canada that does not have a predominantly British and French ethnic heritage. In the late 1800s and early 1900s, settlers arrived from Germany, Russia, Scandinavia, and Eastern Europe to farm the undeveloped land.

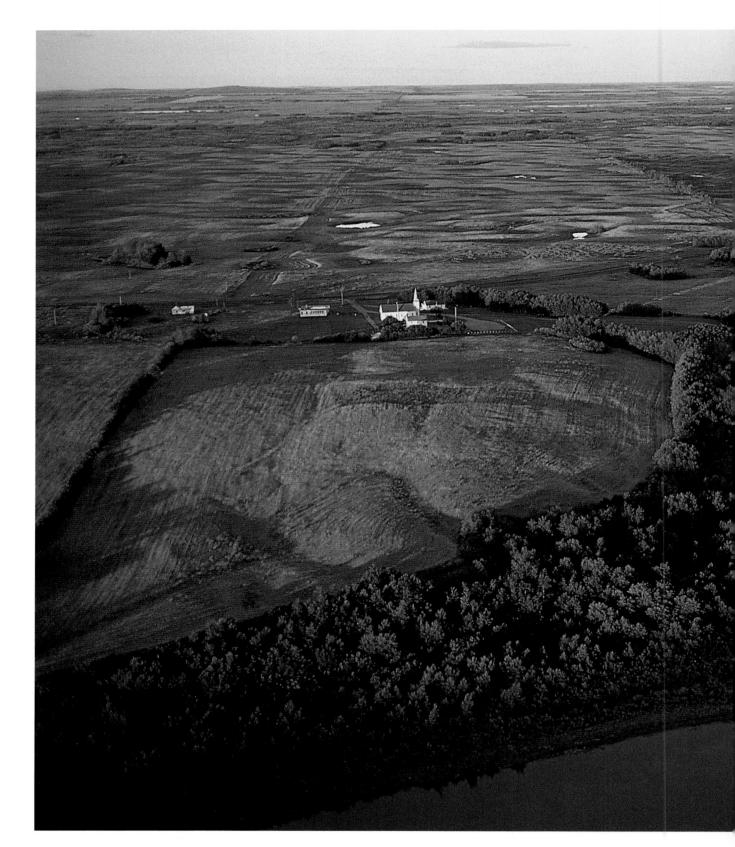

Each of Saskatch-ewan's major river systems—the North and South Saskatch-ewan, the Assiniboine, and the Churchill—flows through Manitoba and empties into Hudson Bay.

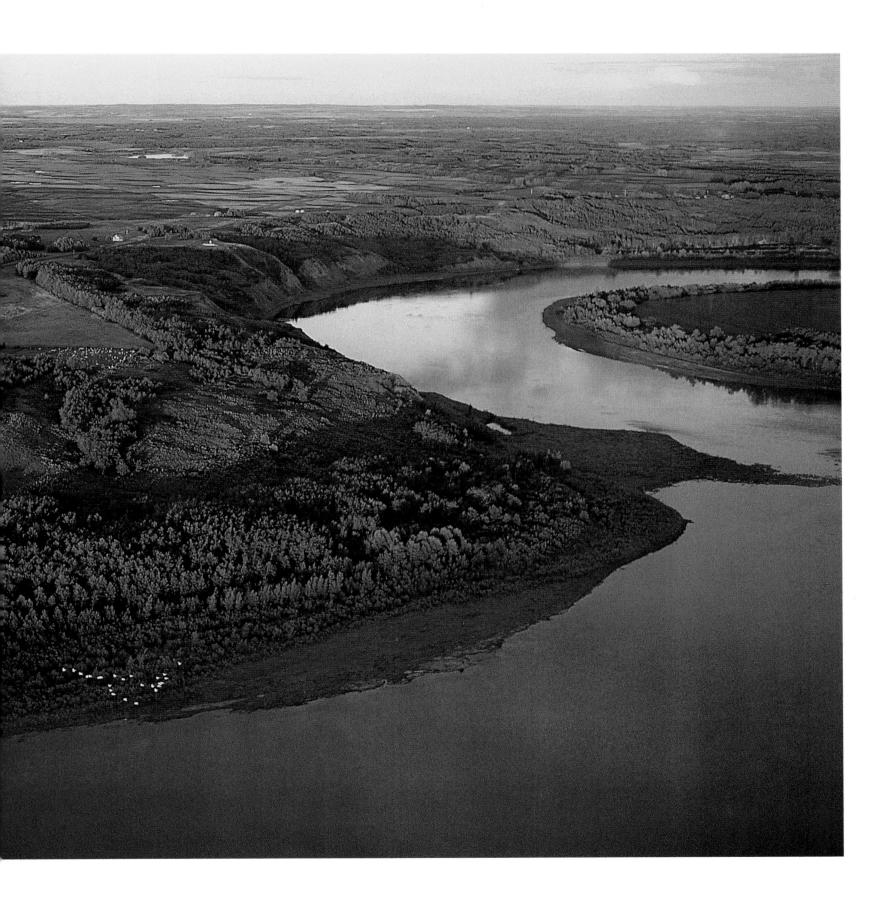

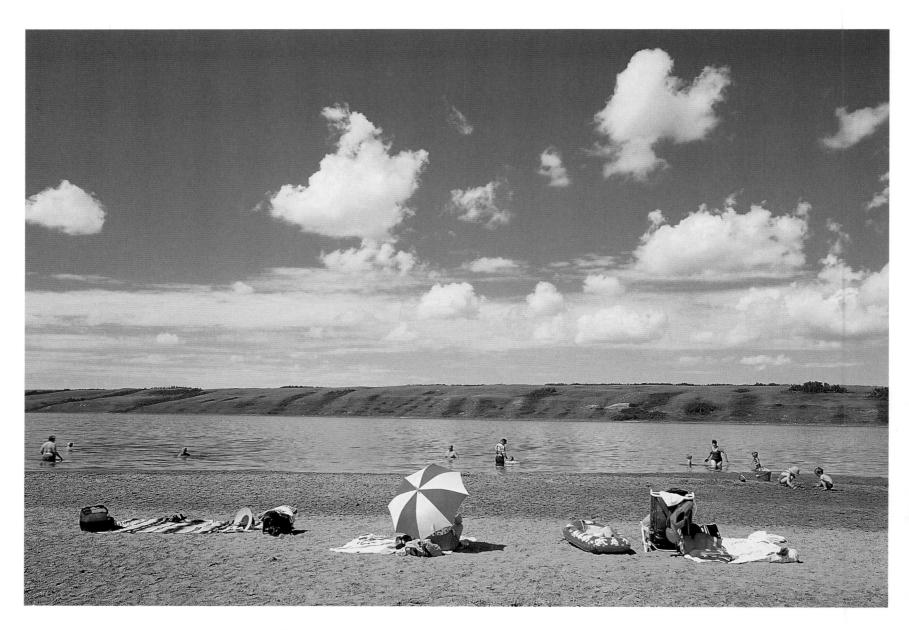

Sunseekers relax on the shores of Little Manitou Lake. For centuries, people have come here for relaxation and healing. Fed by underground springs, the lake is rich with minerals and has such a high salt content that it's impossible for swimmers to sink. In fact, the waters here are denser than those of the Dead Sea.

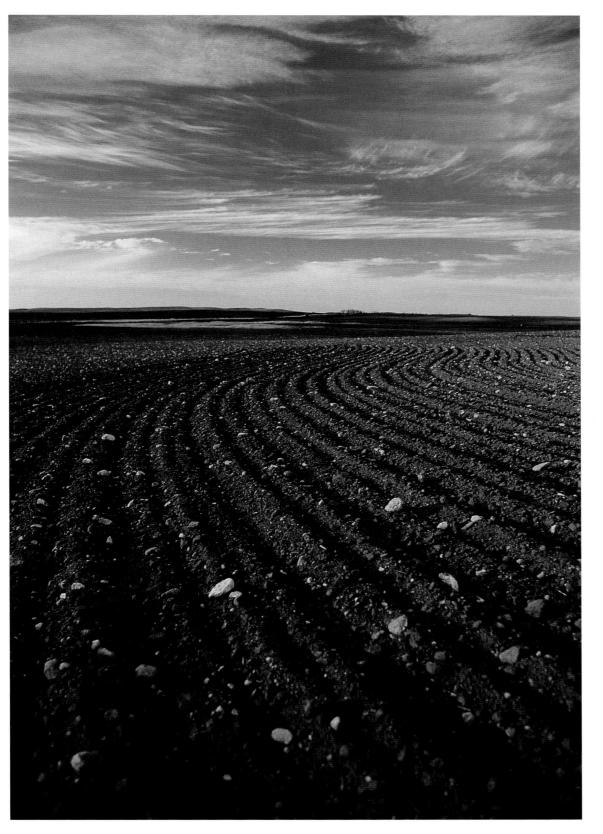

Alberta, Saskatchewan, and Manitoba grow 90 percent of Canada's barley and rye and much of the country's canola.
Nicknamed Canada's Breadbasket, Saskatchewan also produces more than half of the nation's wheat crop.

Protected by the Rockies on one side and the expanse of eastern Canada on the other, Saskatchewan receives less precipitation than any other province. Most falls from May to August, leaving the fall harvest months relatively dry.

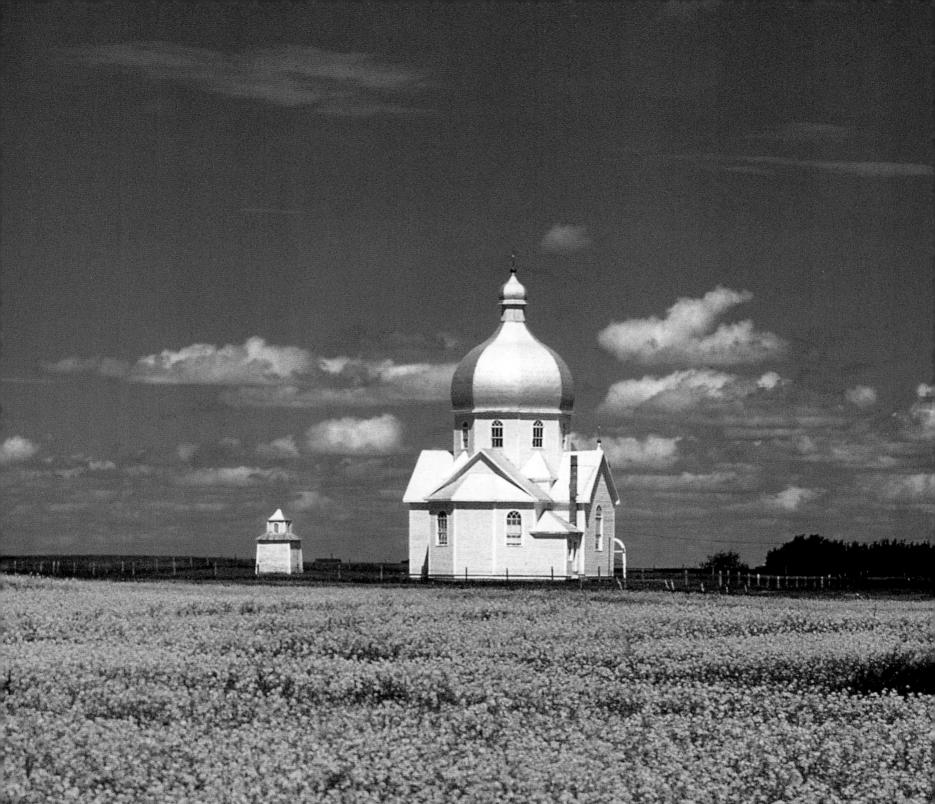

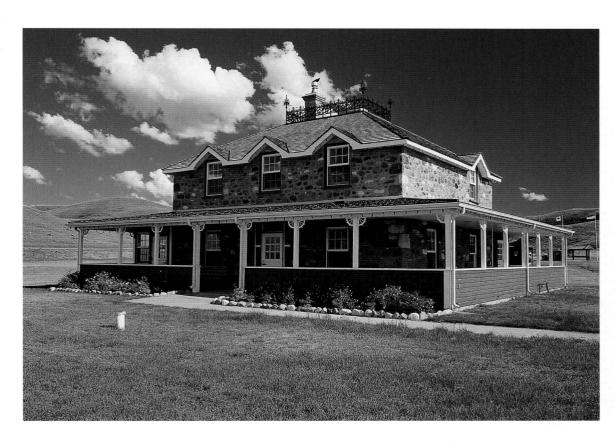

For each person in Saskatchewan, there are two hectares (five acres) of parkland—a total of two million hectares (five million acres). Saskatchewan Landing Provincial Park is one of 25 provincial preserves.

Surrounded by farmland, Swift Current is home to an Agriculture Canada Research Centre. There, scientists study cereal grains, forage crops, soil, and dryland agriculture, hoping their findings will increase crop production and quality.

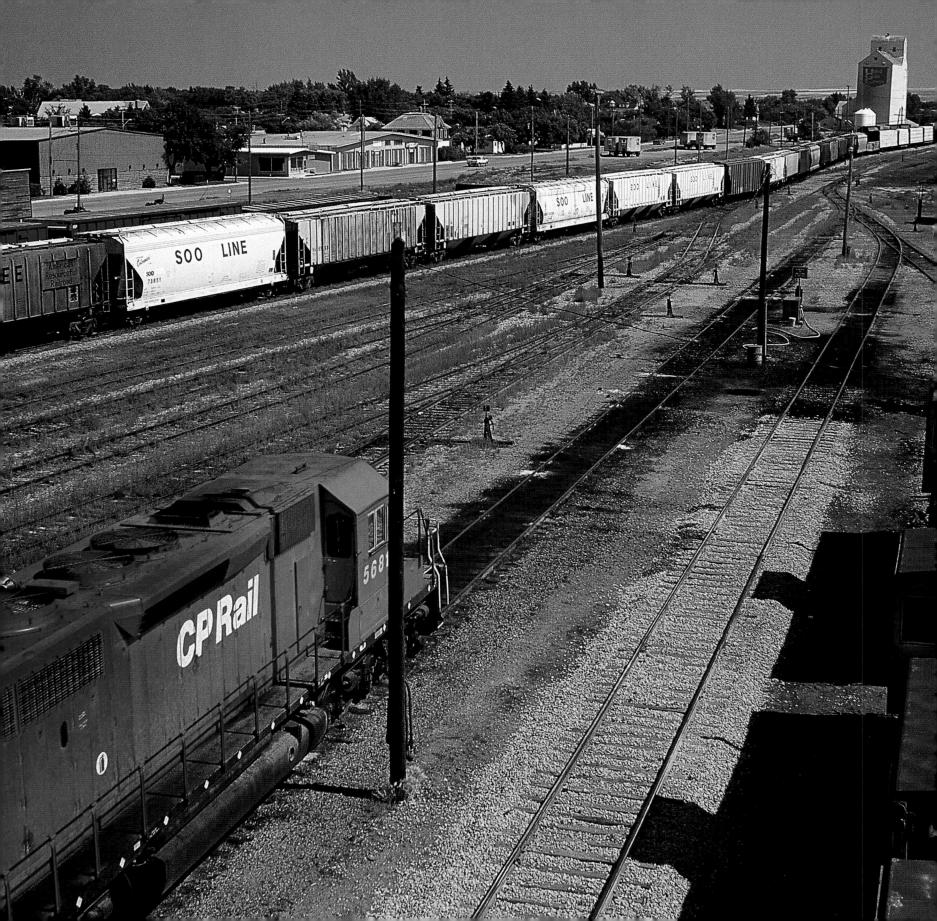

The population of Swift Current swelled as more and more immigrants arrived from Europe. In 1914, it became one of the province's first cities. About 16,500 people now live here.

Swift Current boomed with the arrival of the railway in the 1880s. A 120-metre (400-foot) dam was built along the river to provide water for the steam engines, and a Canadian Pacific Railway station was established.

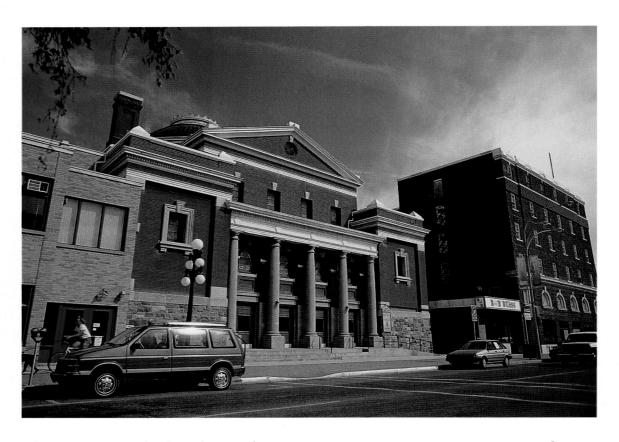

The Zion United Church stands on Main Street in Moose Jaw. Created as a union of Methodists, Congregationalists, and Presbyterians in 1925, the United Church now has about three million followers in Canada.

A *Tyrannosaurus rex* skeleton unearthed near Eastend in 1994 is one of just a dozen found in the world. The Eastend Tourism Authority and the Royal Saskatchewan Museum work together in the region, continuing to research the rich fossil beds.

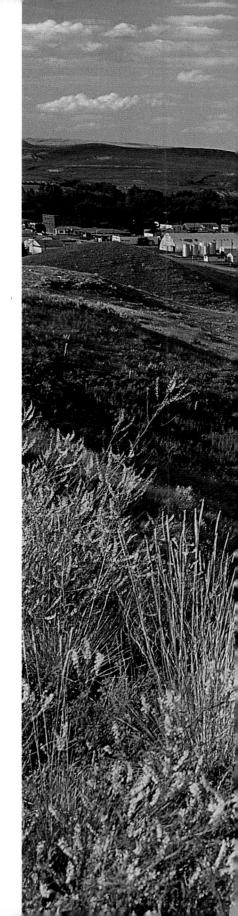

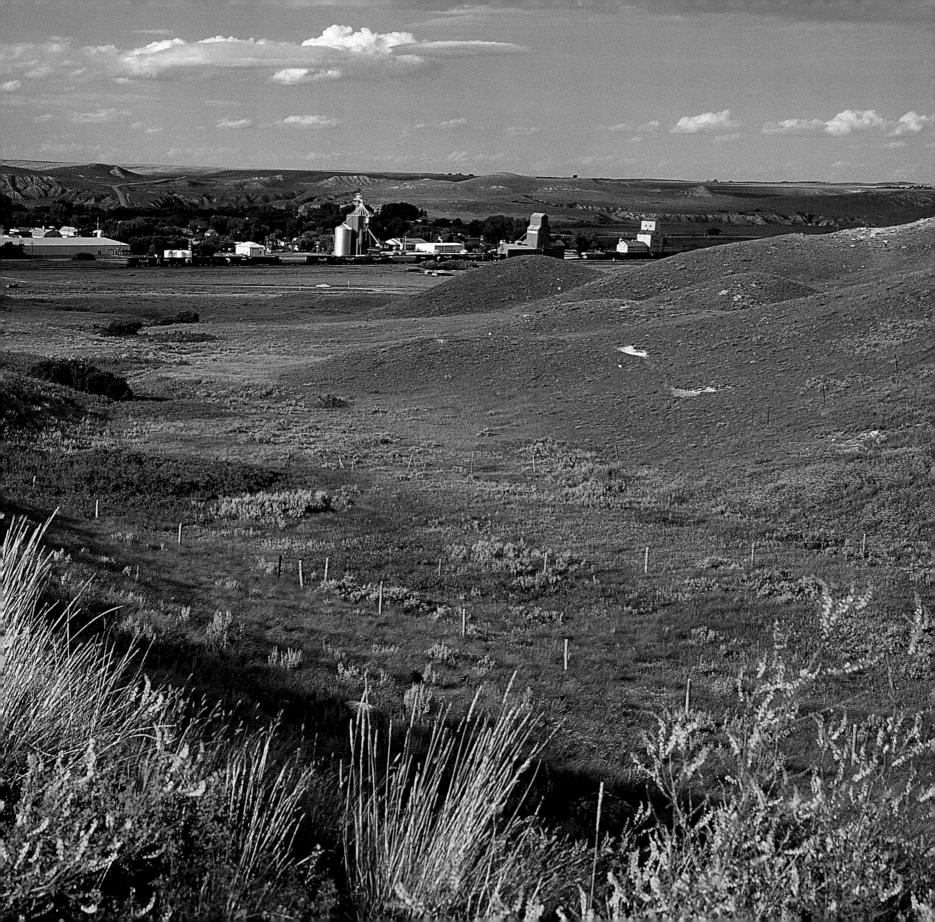

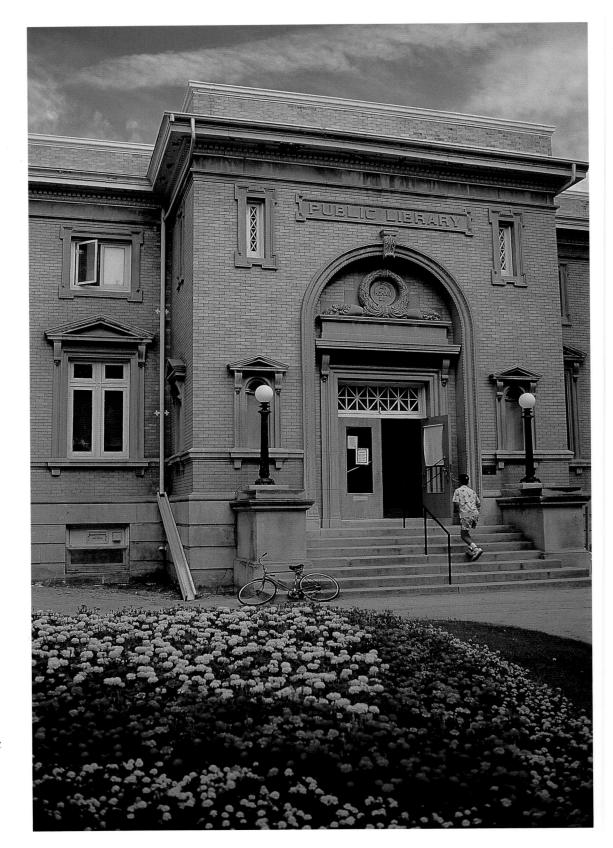

Moose Jaw was thriving in the early 1900s, due to the arrival of the railway and the influx of immigrants. Sightseers today can tour the tunnels of "Little Chicago" and experience the era of prohibition, when smugglers used these underground passages in an illegal liquor trade.

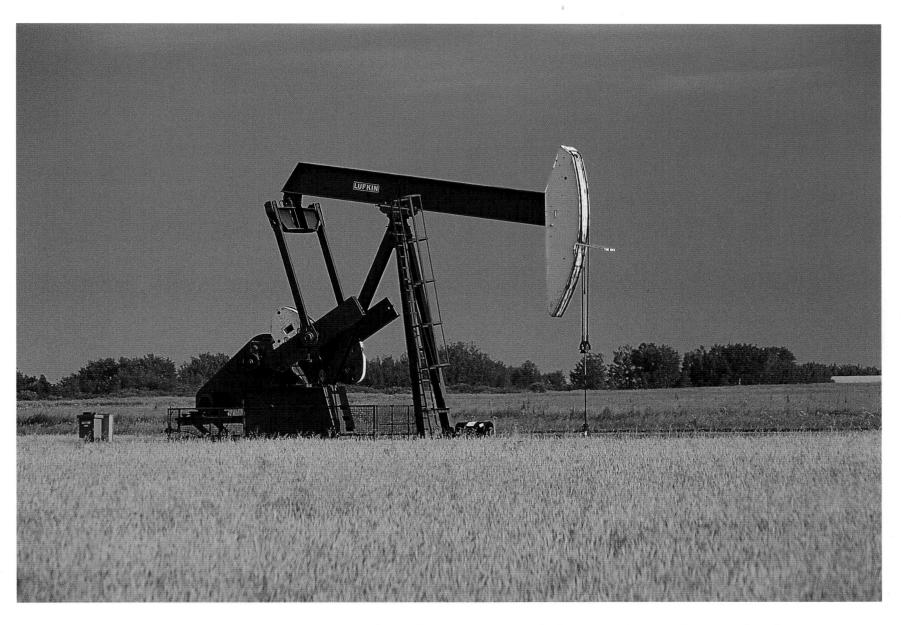

This oil pump is one of about 14,000 wells in Saskatchewan, yielding more than 20 percent of Canada's oil. The first commercial crude oil was discovered here in 1944. About three-quarters of the resources are owned by the provincial government and leased to private development companies.

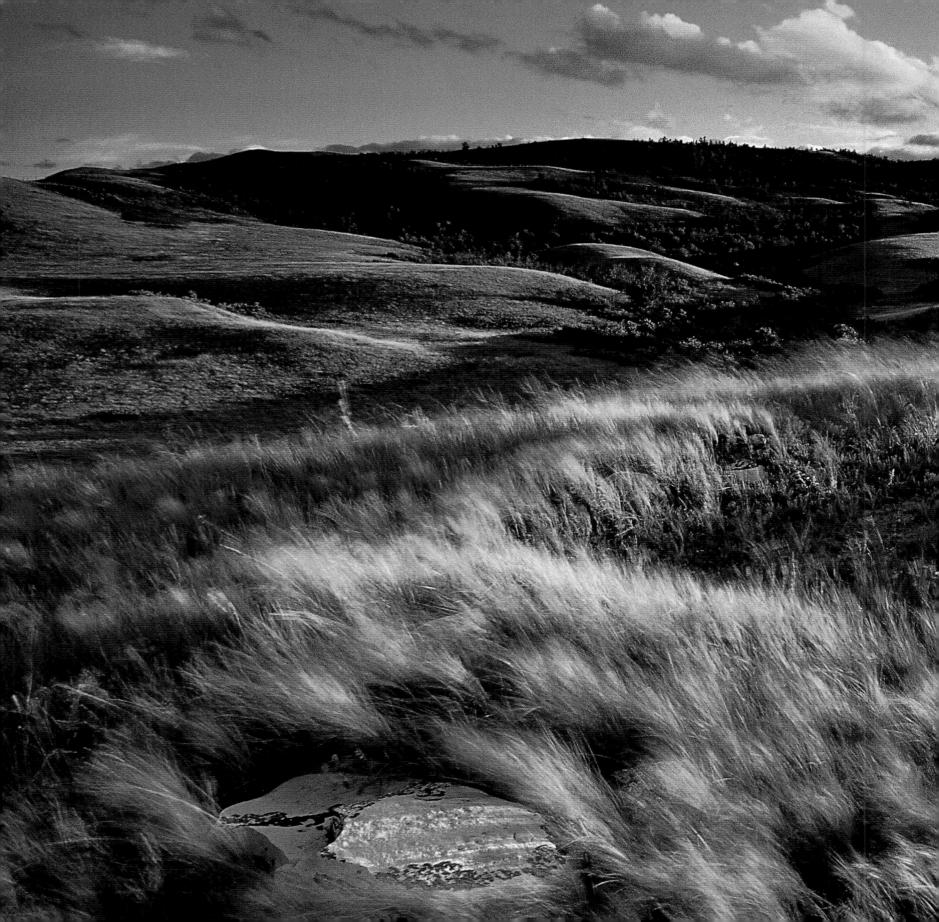

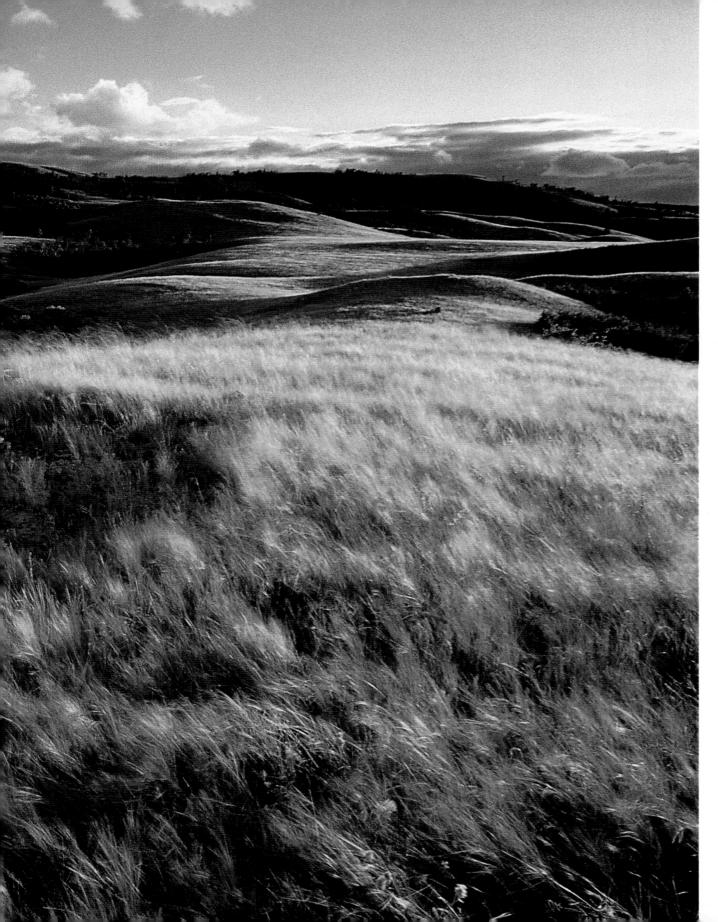

For thousands of years, First Nations people herded bison into enclosures in what is now Buffalo Pound Provincial Park, killing the animals to provide clothing, food, and shelter. The park was established in 1963, and bison were reintroduced to the area about 10 years later.

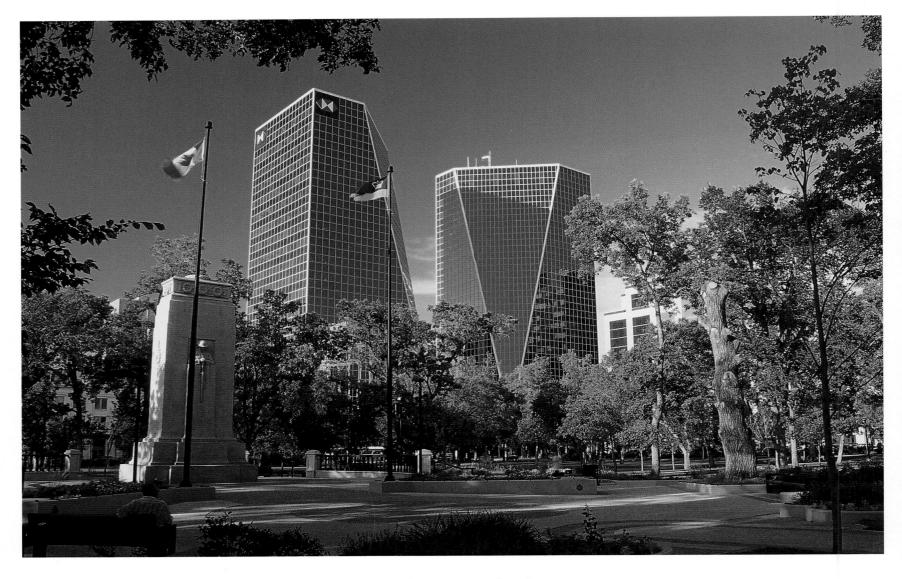

Regina, Saskatchewan's capital, began as a tiny settlement on the shores of Pile o' Bones Creek, named after the stacks of bison bones left on the banks by First Nations hunters. When Princess Louise visited in 1882, she christened the community "Regina" for her mother, Queen Victoria.

Nicolle Flats in Buffalo Pound Provincial Park is named after the area's first European settlers. Charles Nicolle and his family arrived to farm the land here in 1881. Their stone home and barn are now historic sites.

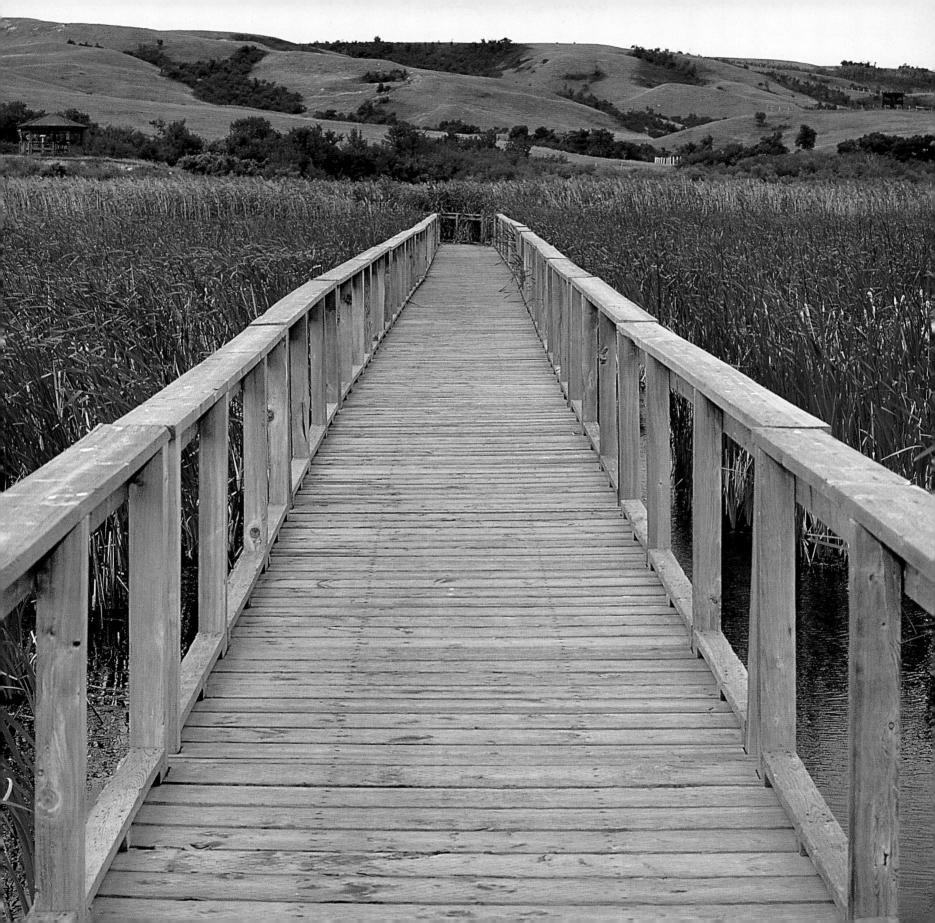

The government asked seven international firms to submit designs for Saskatchewan's Legislative Building. The plans of the Montreal company Edward & W. S. Maxwell were selected, and the building was completed in 1912. The premier at the time, Walter Scott, chose Manitoba's Tyndall limestone for the building's exterior.

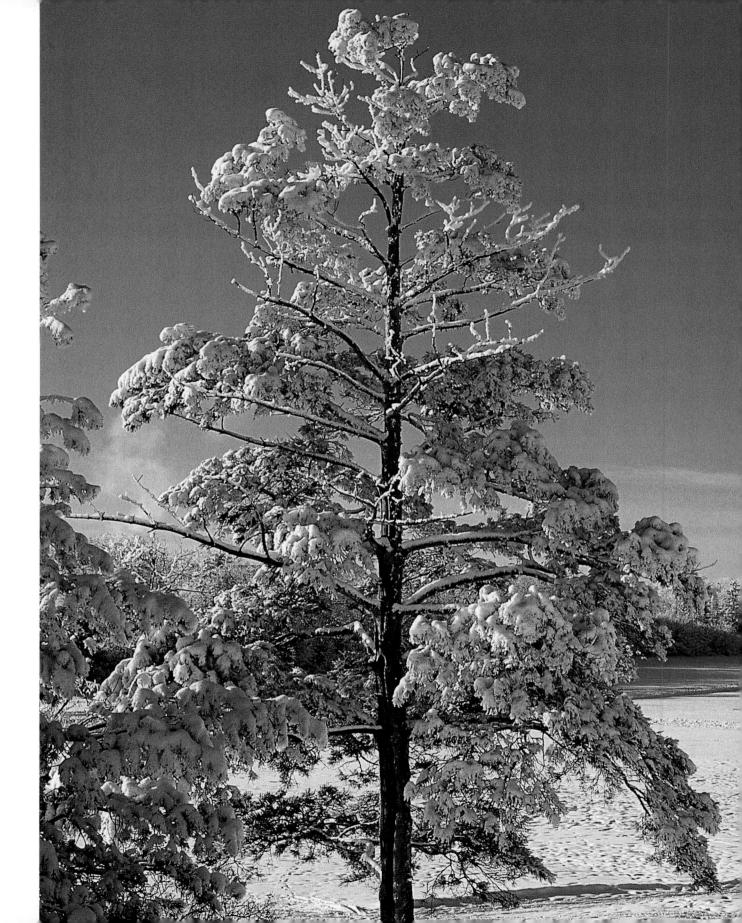

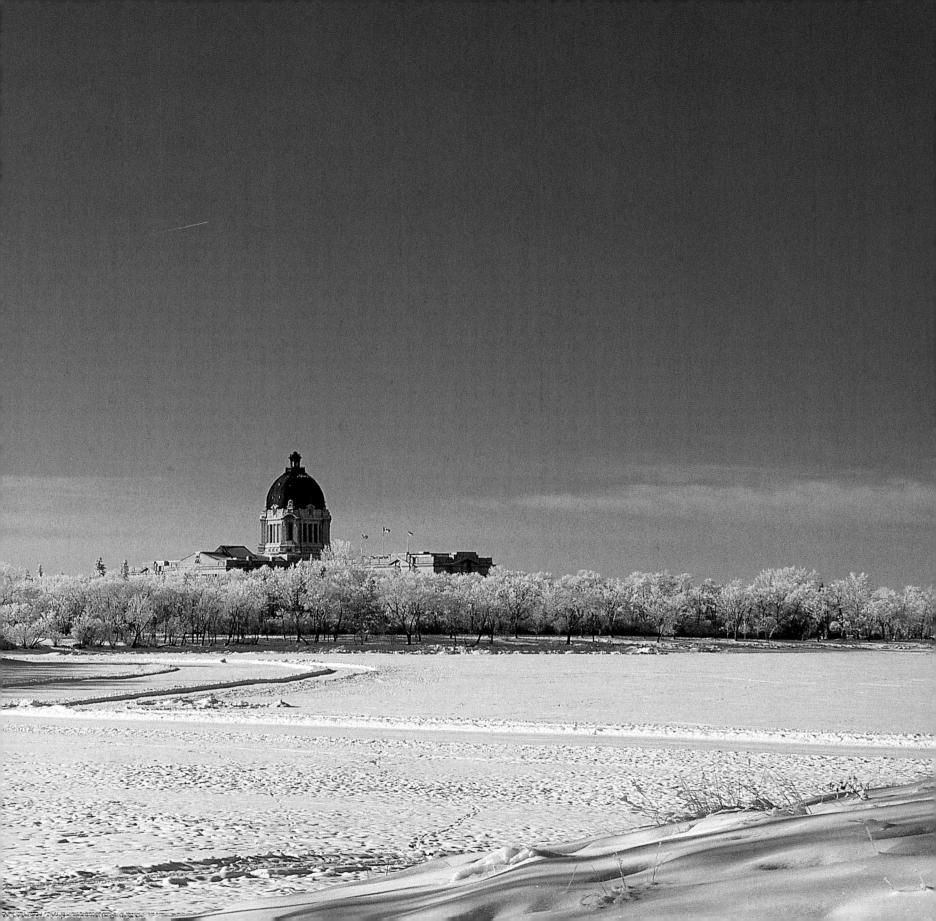

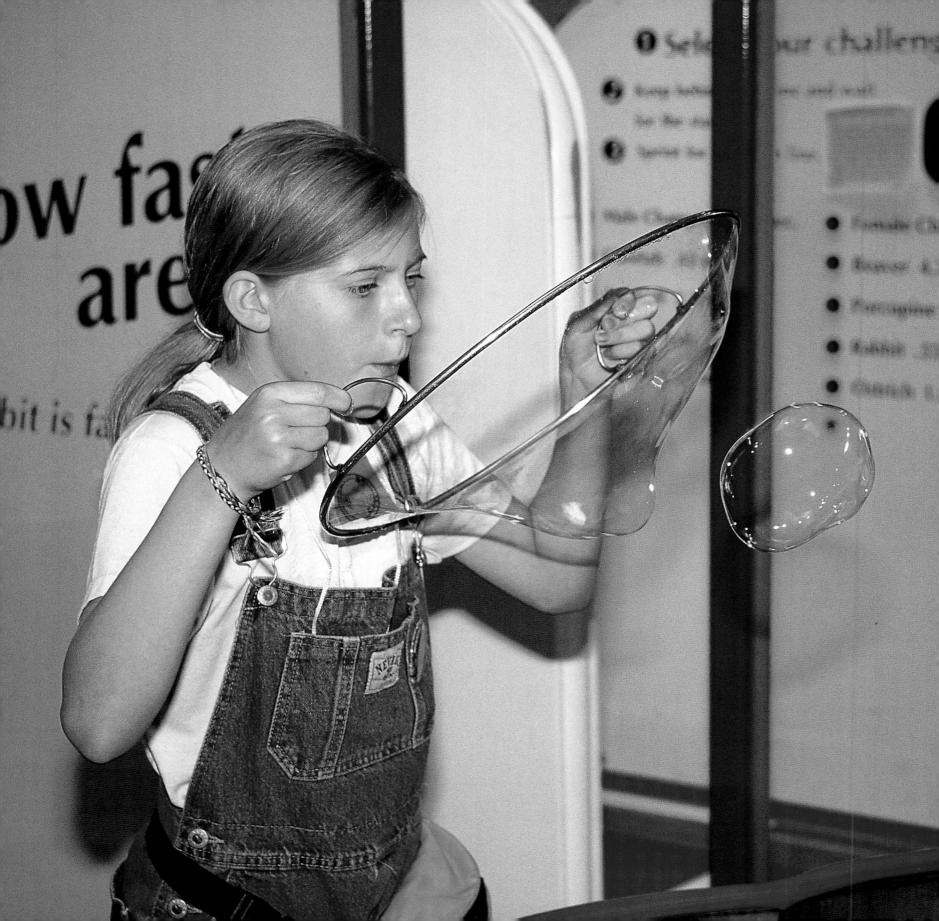

Regina is the home of the Royal Canadian Mounted Police training academy—the force's primary training centre. Almost every officer in the force since 1882 has studied here, learning law enforcement and self-defence, participating in crime scenarios, and more.

More than 80 interactive exhibits—plus a giant IMAX theatre—attract 250,000 children and adults to the Saskatchewan Science Centre each year. Exhibits explore the worlds of physics, ecology, meteorology, space, and animal life.

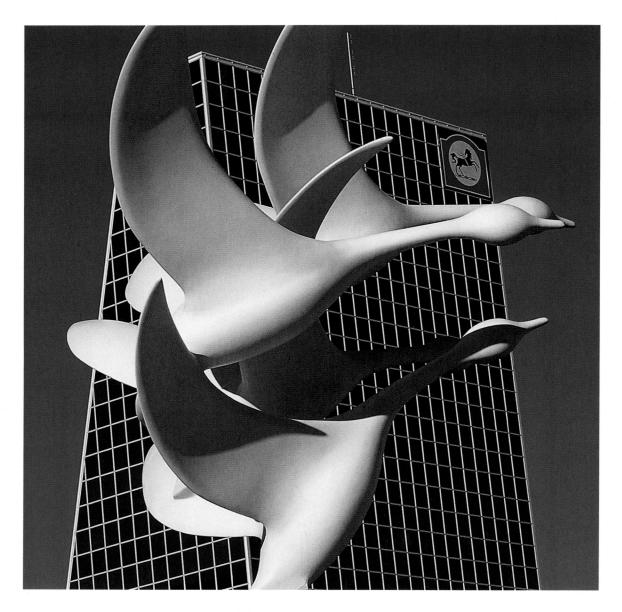

Western Spirit, a sculpture of four Canada geese carved by Dow Reid, stands outside the Canada Trust Building. Regina is Saskatchewan's cultural centre, boasting a wide array of musical, theatrical, and cultural events.

Regina was a small trading community and North West Mounted Police fort until the building of the Canadian Pacific Railway in the late 1800s. Prime Minister Sir John A. Macdonald asked the CPR to select a new capital for the territory, and Regina was chosen.

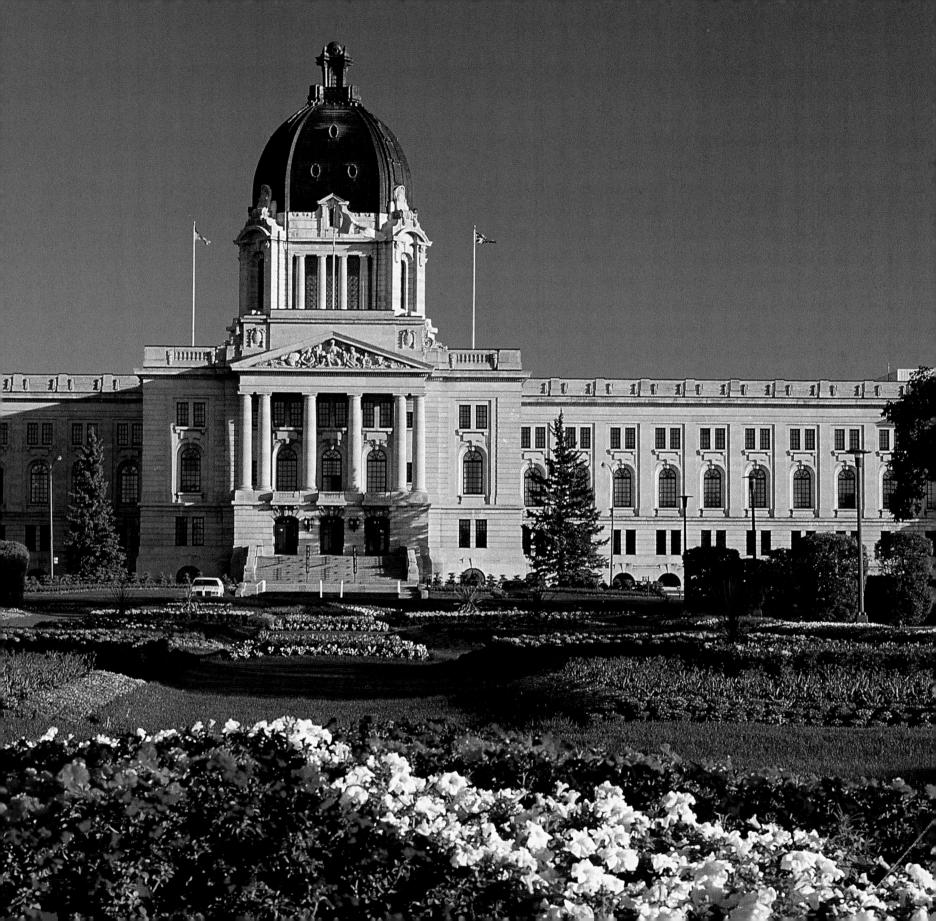

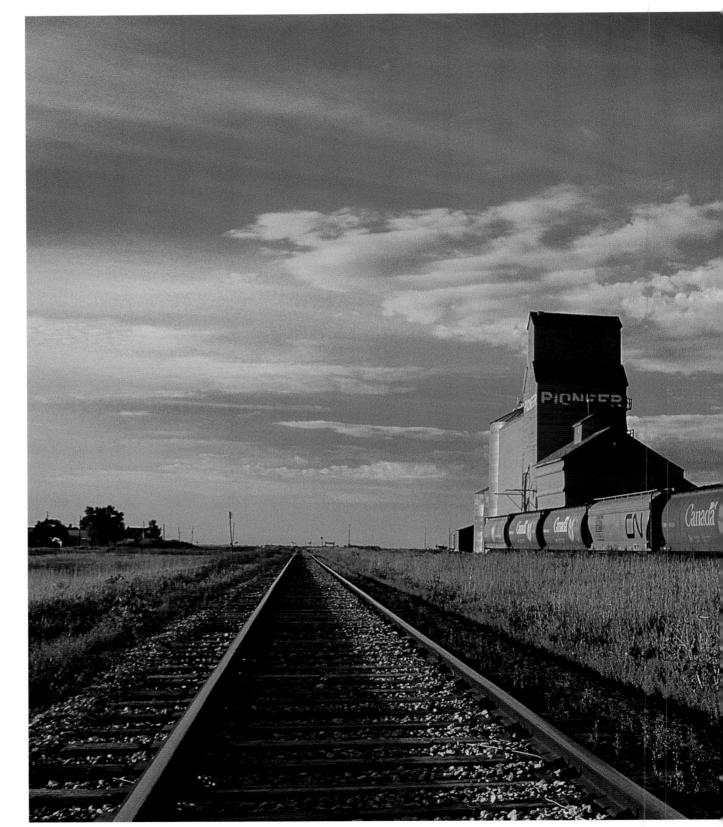

Regina is a commercial centre for the province's agriculture and industry. The head offices of the Saskatchewan Wheat Pool are within the city, as well as those of Credit Union Central, Crown Life. and Co-Operators Insurance.

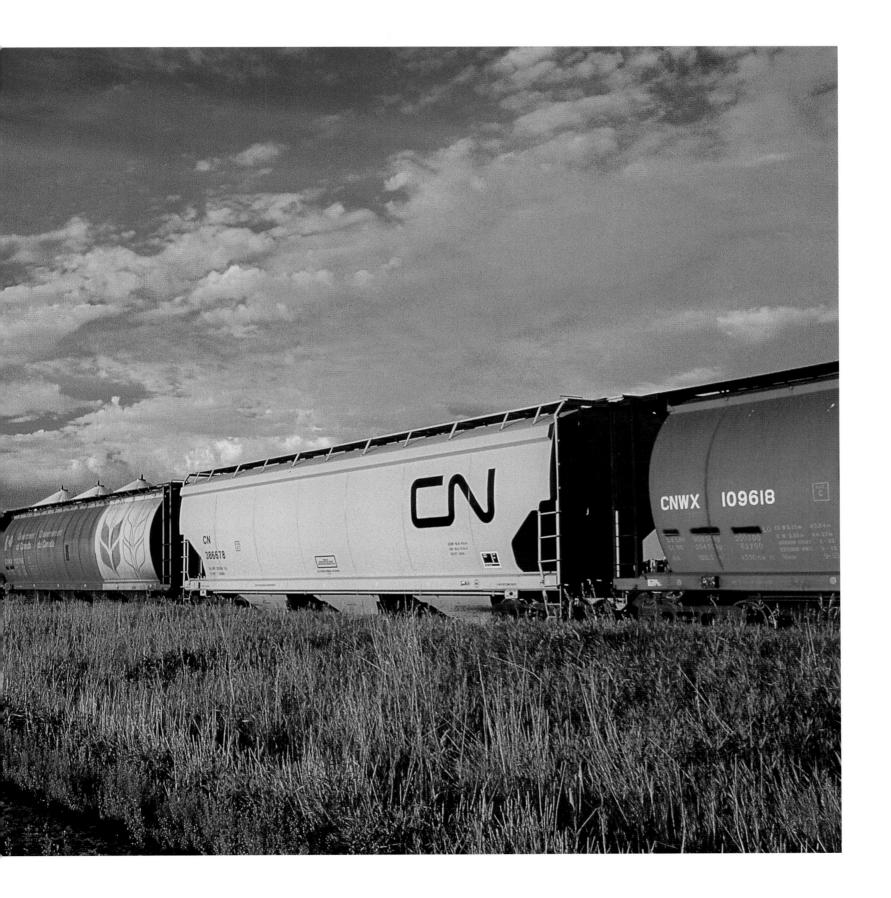

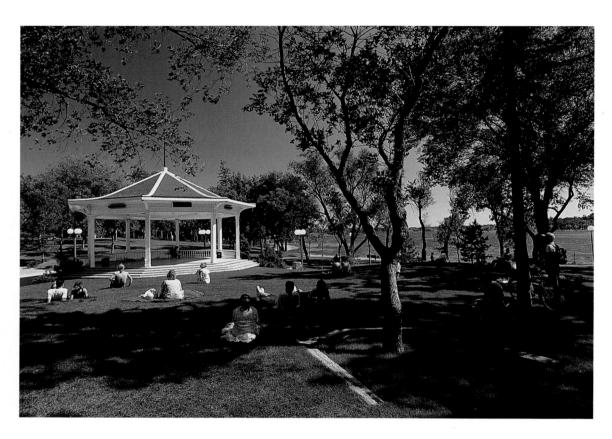

Visitors gather in Wascana Park for one of Regina's many festivals. The SaskPower Festival of Lights features over 150 displays each winter, while Mosaic highlights the cultures of more than 30 nations each summer.

Wascana Park—one of the largest urban parks on the continent — encompasses 930 hectares (2300 acres). The preserve includes the MacKenzie Art Gallery, the Legislative Building, and the Royal Saskatchewan Museum, as well as quiet retreats and manicured gardens.

The church and rectory are all that remain of the Métis village where Louis Riel and his followers were defeated in May 1885 after more than 25 men were killed in an attempt to protect their traditional lands. Louis Riel escaped, but turned himself in three days later.

Along with the rebellion, Batoche National Historic Site commemorates the struggles of the Métis people on the prairies. Park staff members offer a glimpse of life the way it may have been in the late 1800s.

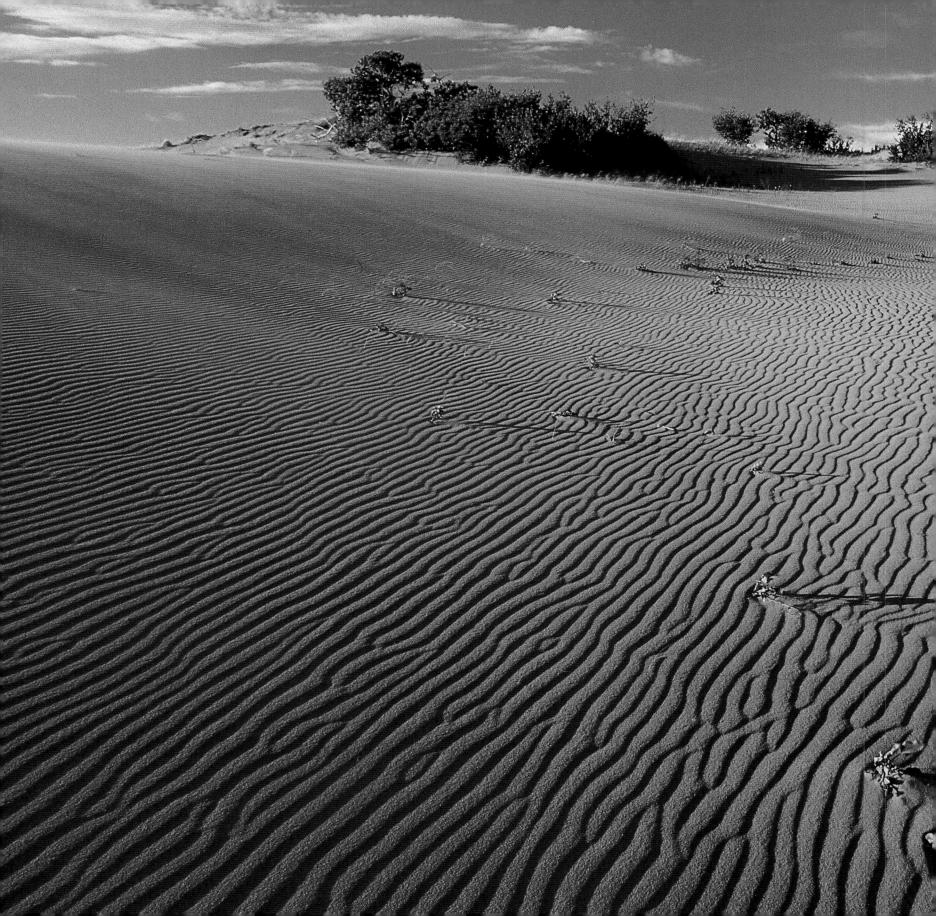

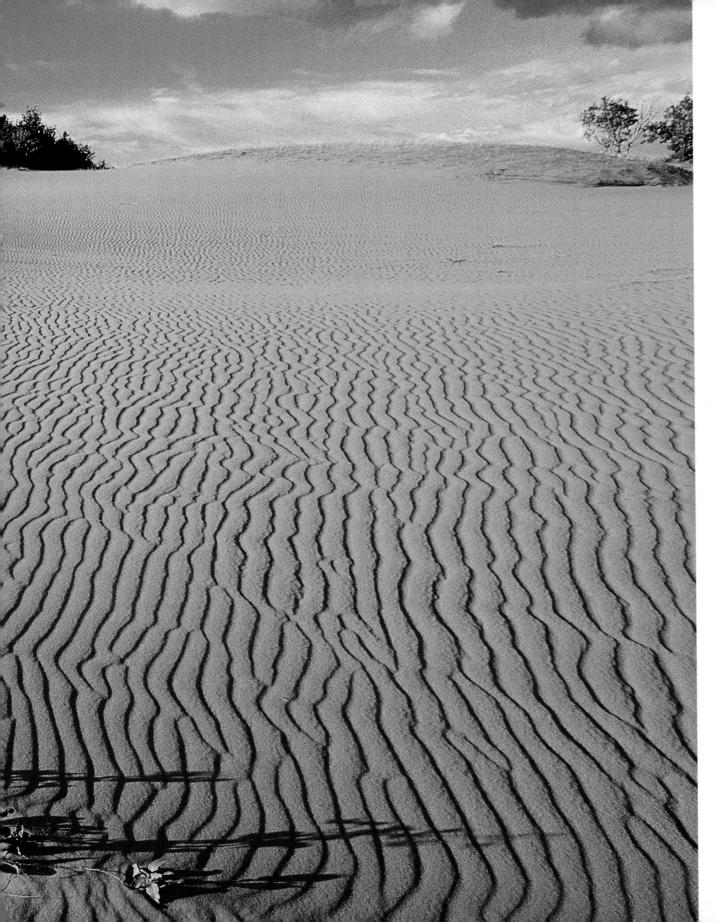

The Great Sandhills, swept bare by the wind, span 1,900 square kilometres (730 square miles) between Maple Creek, Leader, and Webb. They are the largest connecting dunes in the prairies, and home to coyotes and deer as well as bird and reptile species.

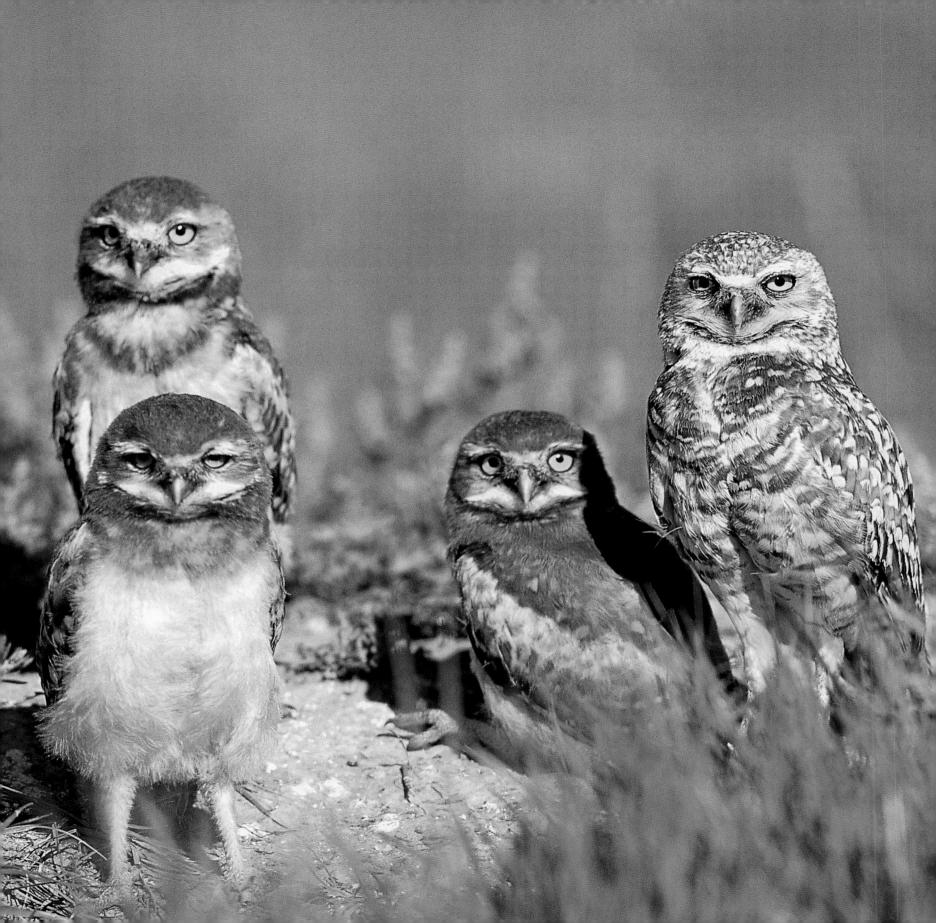

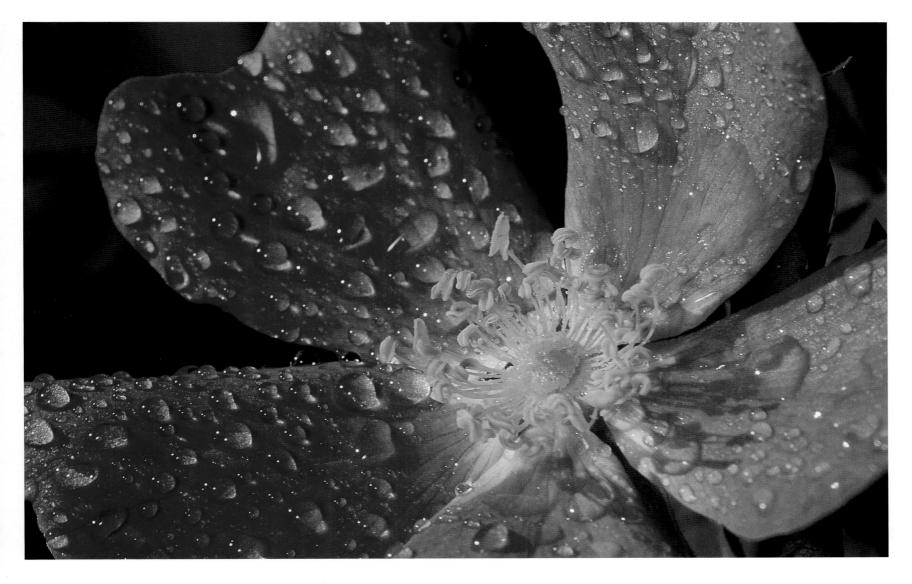

According to a First Nations legend, the prairie rose tamed the storms caused by the Wind Demon. When he caught the flower's sweet scent, his heart softened, and he blew only gentle breezes over the grasslands.

The burrowing owl is only about 23 centimetres (nine inches) tall. Nesting in the abandoned dens of prairie dogs, these birds are threatened by the use of insecticides and by the continuing loss of habitat.

There are more than 100,000 lakes scattered throughout the province, along with several major river systems—the North and South Saskatchewan, the Assiniboine, and the Churchill. The Cree name for Saskatchewan, kisiskatchewan, means "the river that flows swiftly."

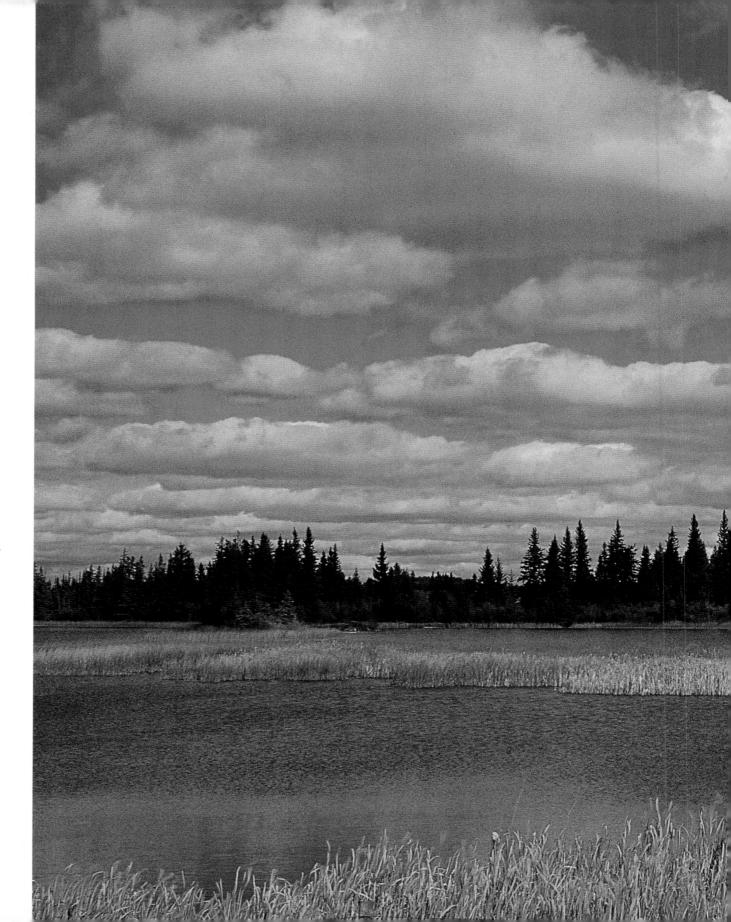

The aspen forests of Duck Mountain Provincial Park are a popular escape for city dwellers yearround. Swimming, boating, and fishing attract summer visitors, while more than 80 kilometres (50 miles) of crosscountry ski trails and an equal abundance of snowmobiling routes entertain winter guests.

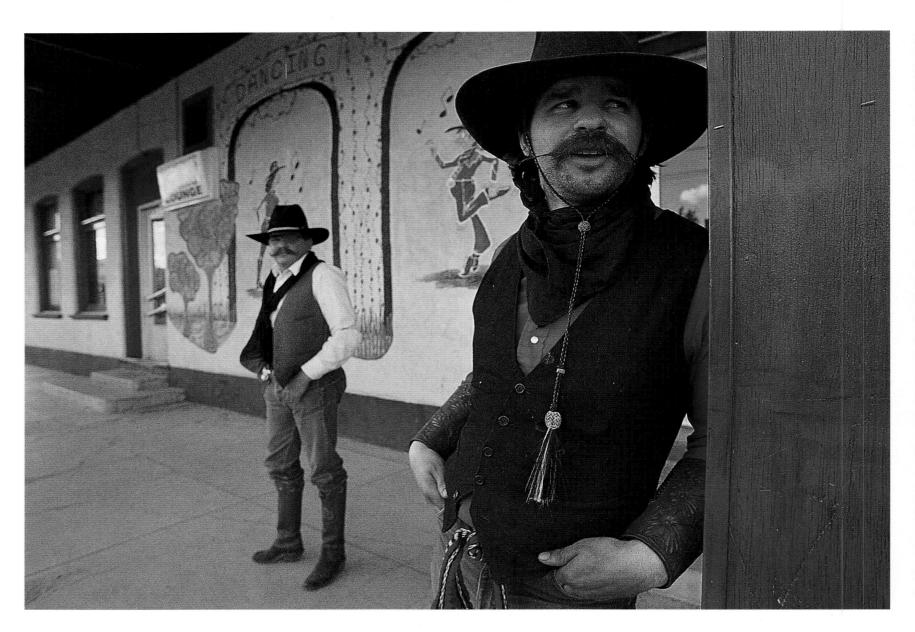

Not many people remember Saskatchewan's role in the Wild West. The Big Muddy Badlands were once the domain of outlaws, including the legendary Butch Cassidy. According to local legend, caves in the area helped Cassidy escape the American authorities, and were part of the famed Outlaw Trail between Canada and Mexico.

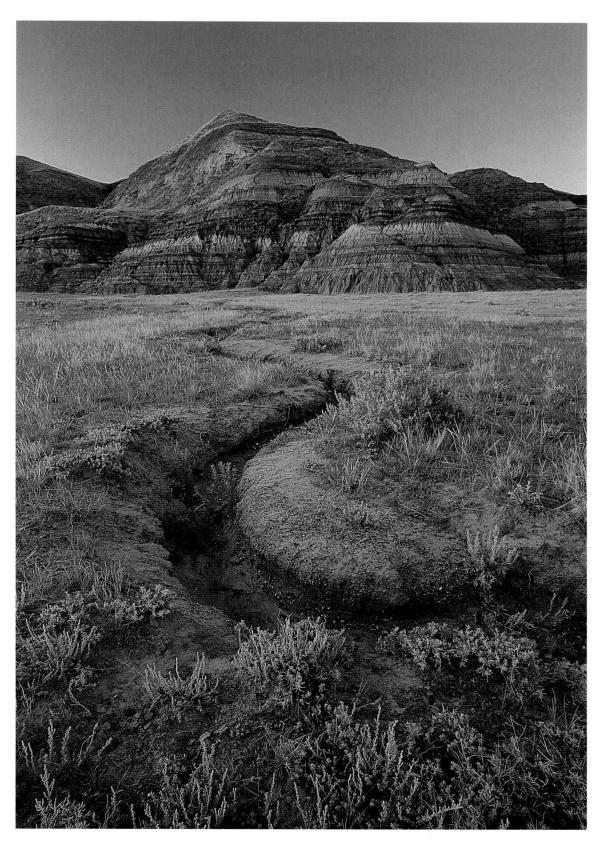

Castle Butte rises 60 metres (195 feet) from the plains, a clay formation that has survived centuries of erosion.

Millions of years ago, this land was a sub-tropical swamp, home to giant sequoia, magnolia trees, and dinosaurs.

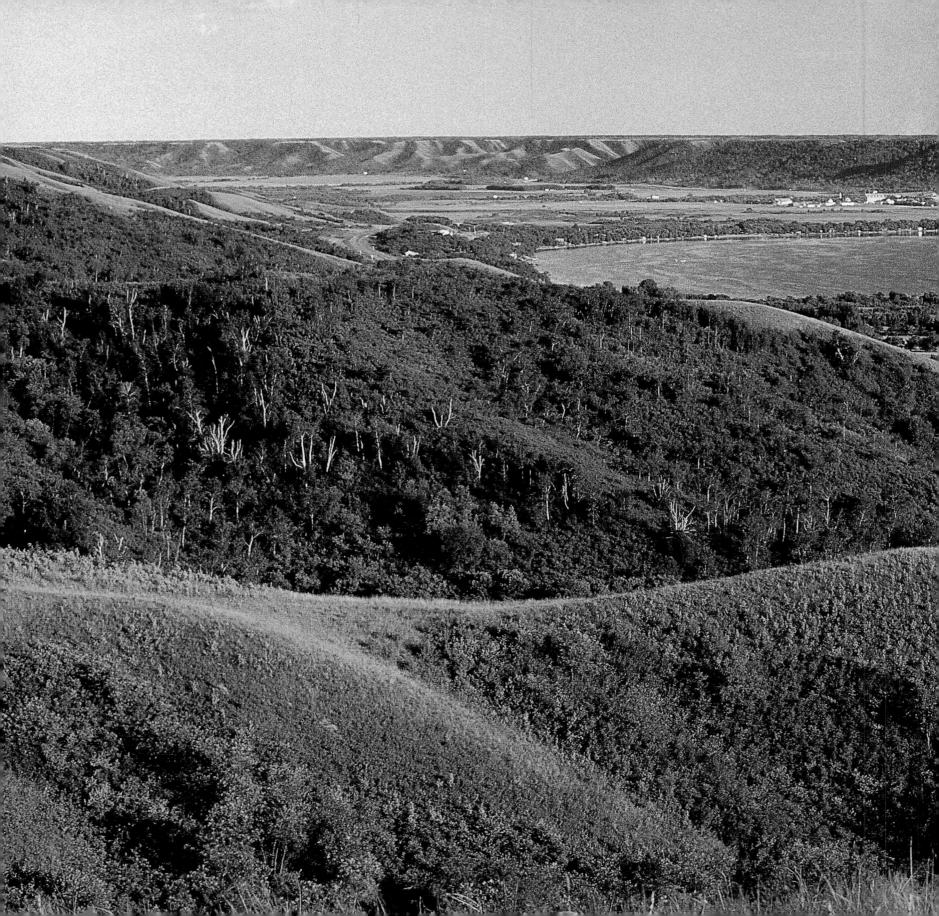

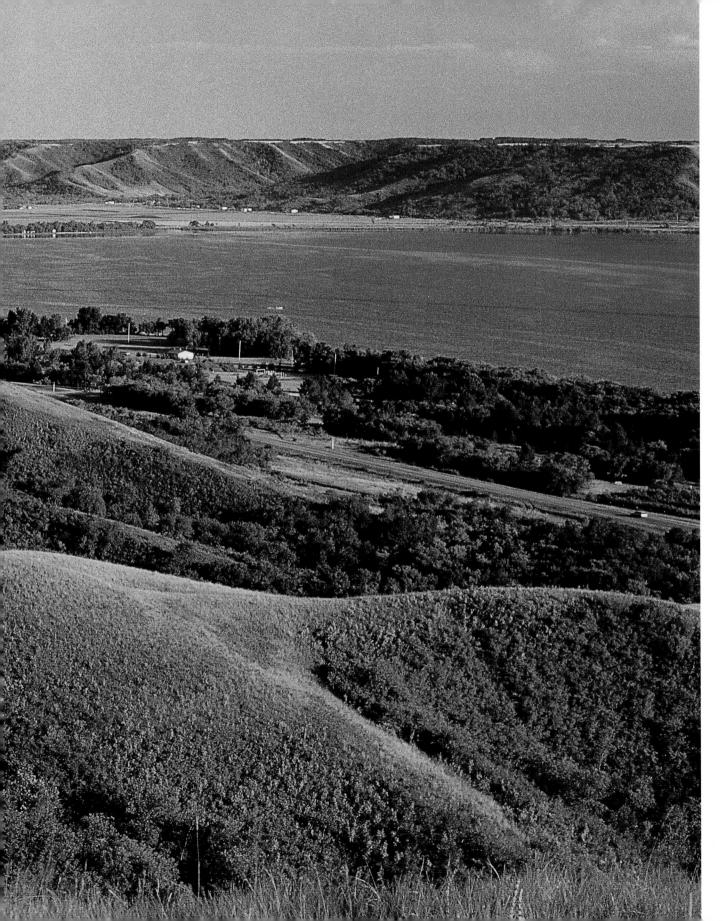

According to First
Nations legend, a
young man once
heard echoes in the
Qu'Appelle Valley
calling his true love's
name. Qu'Appelle
means "who calls?"

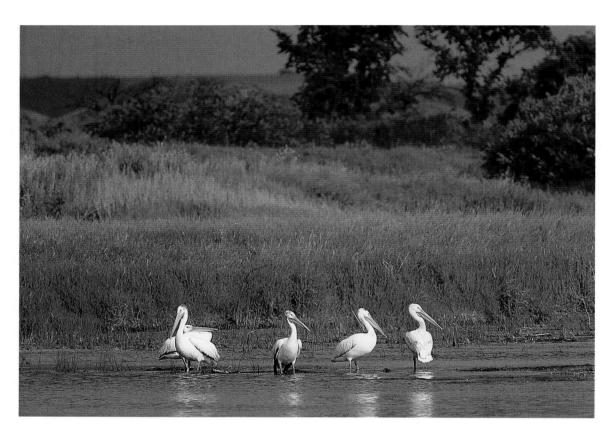

American white pelicans spend their summers feeding and breeding on the lakes of the plains, migrating to the southern United States for the winters.

Canada's population exploded from just over five million in 1901 to more than seven million in 1911. Many of the new immigrants flocked to Saskatchewan, lured by free land and Prime Minister Wilfrid Laurier's promise that the twentieth century belonged to Canada.

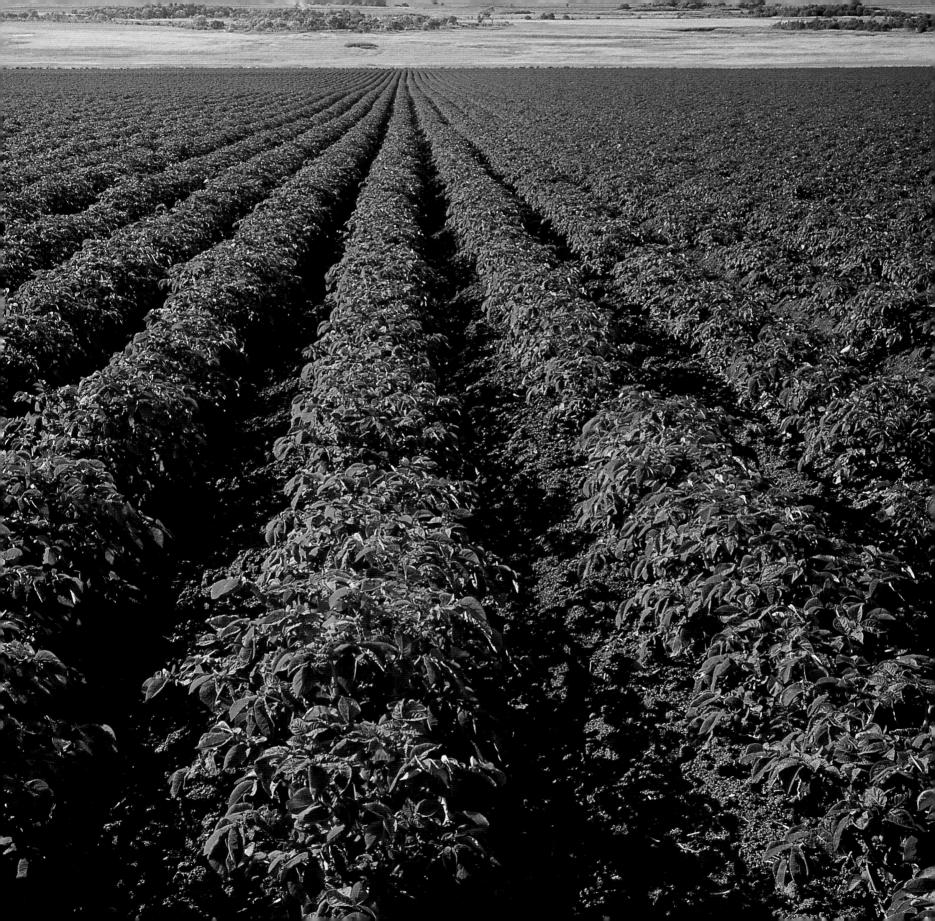

The Qu'Appelle Valley is also known as the Valley of the Calling Lakes. It's easy to see why Katepwa Point Provincial Park calls visitors to return again and again. The park protects a serene eight hectares (20 acres) of hill-sides, picnic areas, and lakeshore.

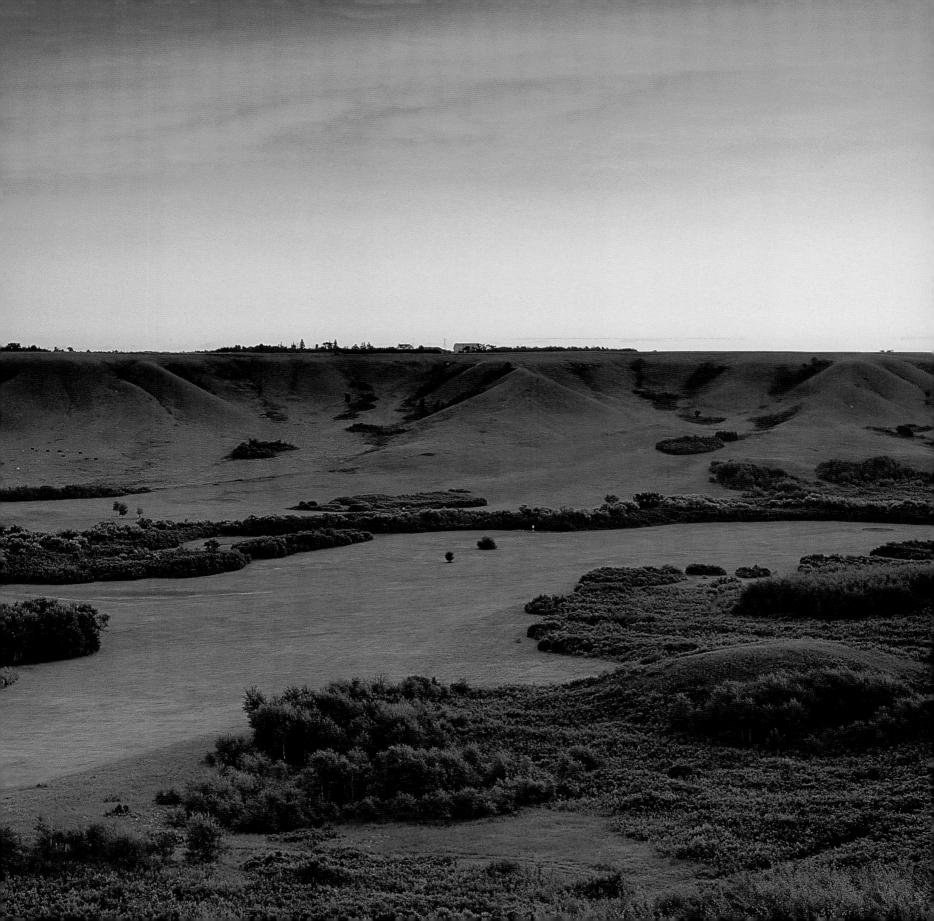

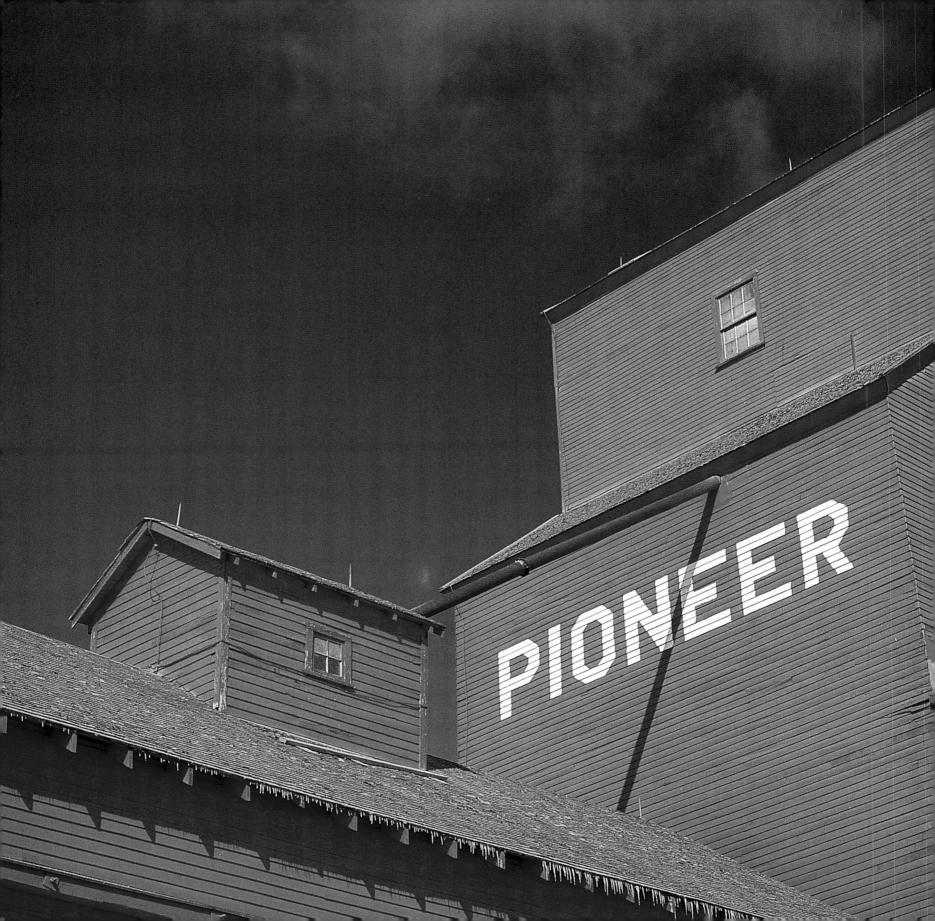

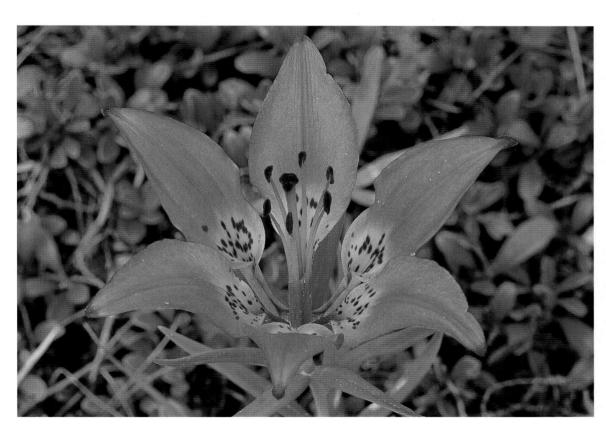

The western red lily is Saskatchewan's official flower. A protected species, it flourishes only in damp clearings and along forest edges.

Canadian grains are not used only in bread products. Pasta, crackers, mustard, and licorice are just a few of the more unusual things made from crops grown in Saskatchewan.

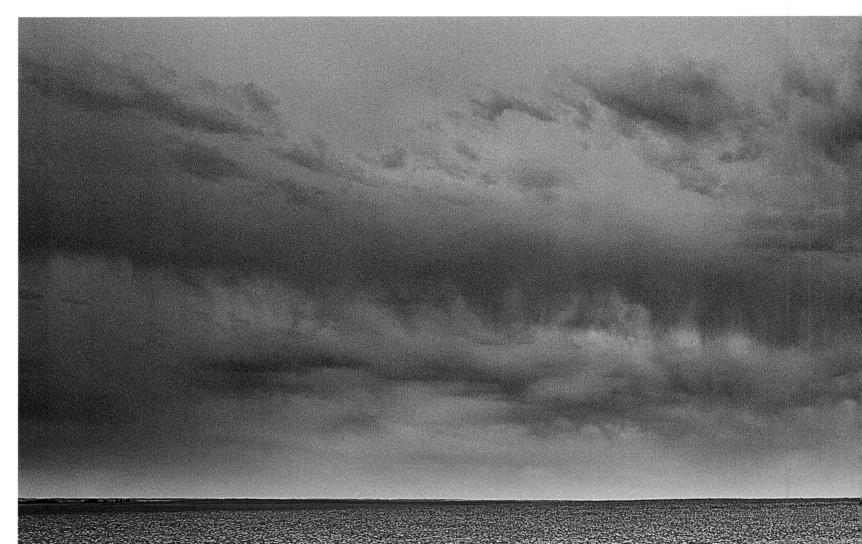

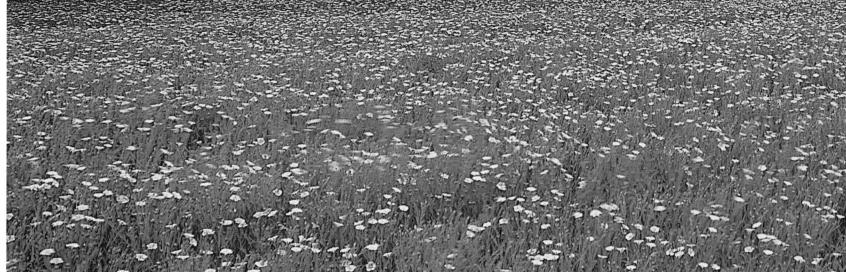

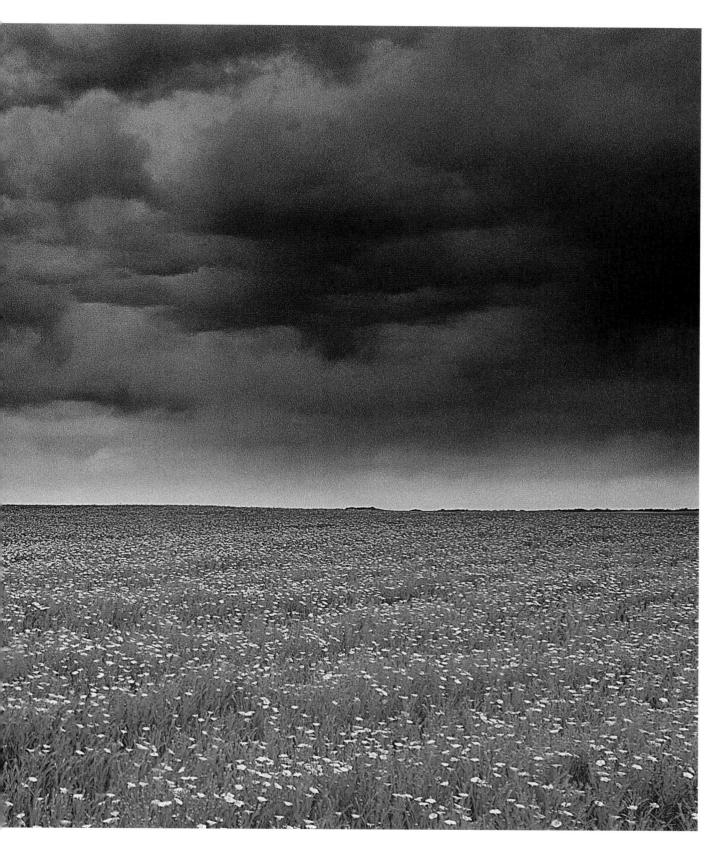

Saskatchewan's flax crop is an important food grain. The plant is also used to make linseed oil—an ingredient in paints, wood stains, and varnishes—and the fibre is used to strengthen paper, plant pots, and mats.

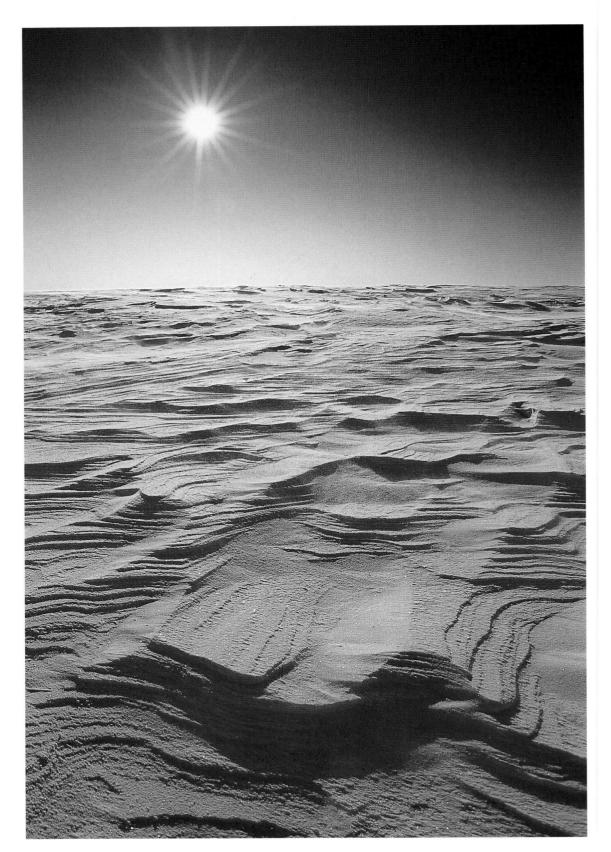

Snowfall in Saskatchewan varies from 100 centimetres (40 inches) a year in the south to 175 centimetres (70 inches) in the north. Protecting the earth from erosion and replenishing the soil's water supply, the snow is essential for the province's agriculture.

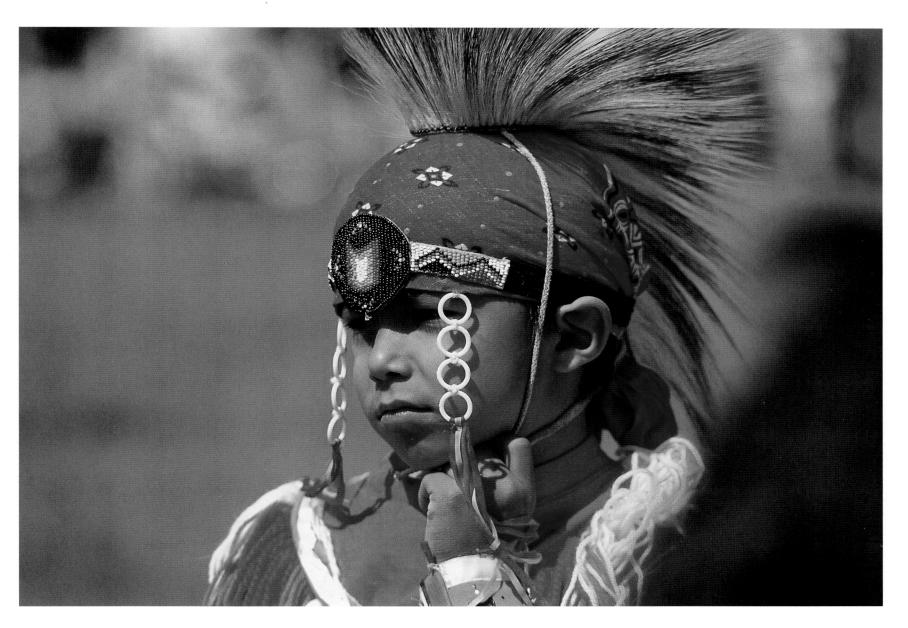

A young boy participates in the fast-paced and colourful grass dance at a powwow in southern Saskatchewan. These traditional celebrations take place in many Saskatchewan towns throughout the summer, and often involve dancing, drumming contests, arts and crafts displays, and more.

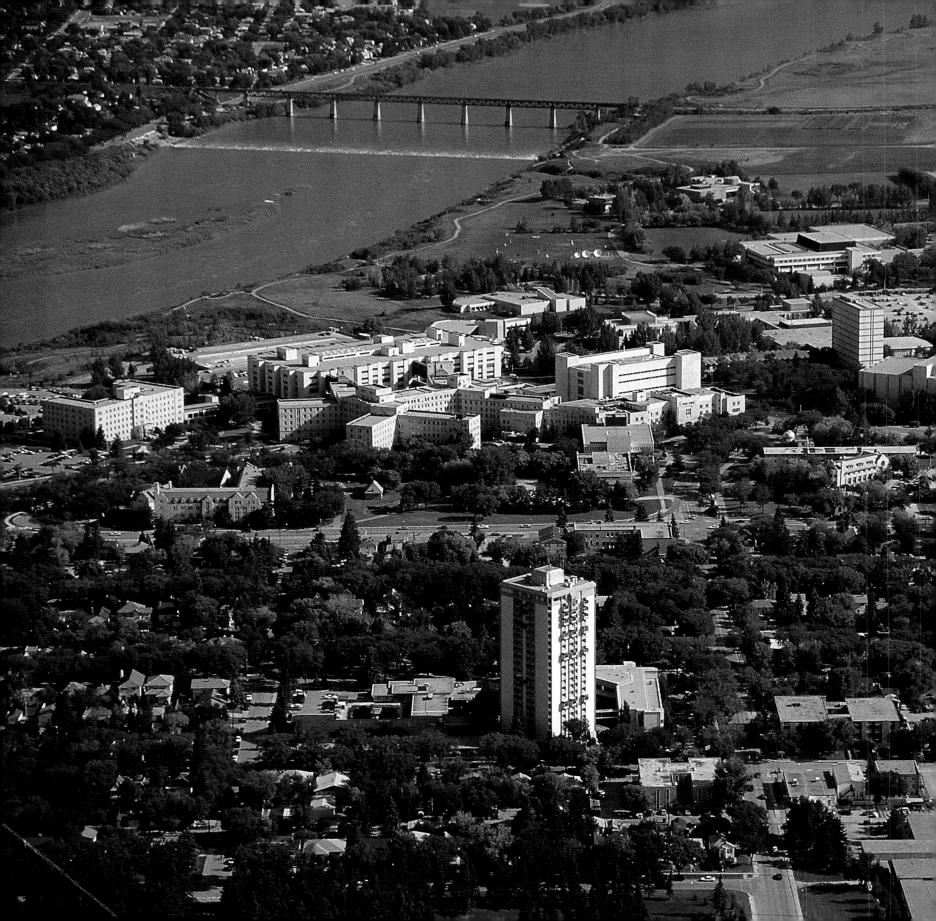

With midways, a parade, children's events, and art shows, the Saskatoon Exhibition attracts crowds from across the province each August.

In the 1880s, the government granted a large plot of land on the banks of the South Saskatchewan River to the Temperance Colonization Society, a group of Toronto-based Methodists searching for a new way of life. In 1900, just over 100 people lived here. Saskatoon is now Saskatchewan's largest city, with a population of more than 200,000.

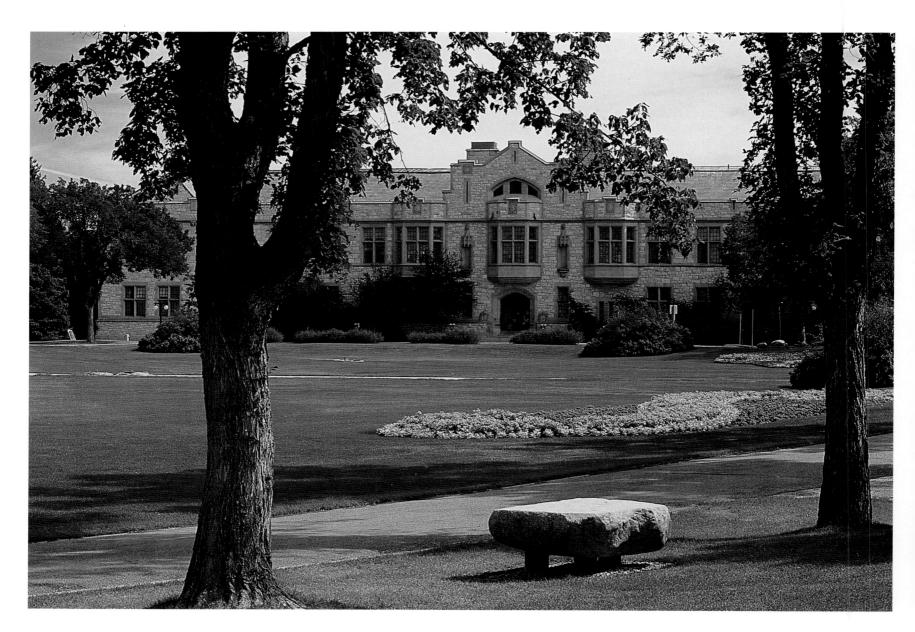

The University of Saskatchewan held its first classes in 1909, with a total enrollment of 70 students. Students can now choose among 58 degree programs, ranging from law and medicine to agriculture and commerce.

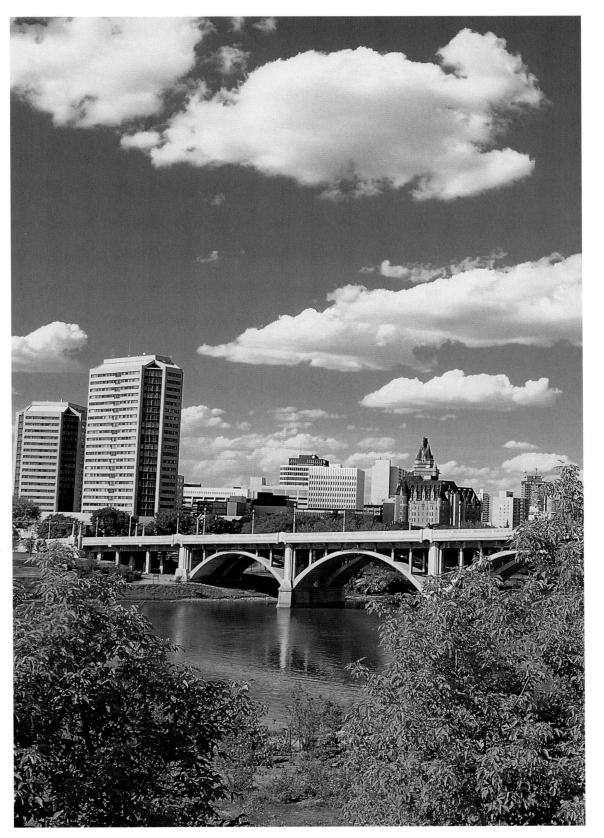

Saskatoon's name comes from the Cree word mis-sask-quahtoomina—Saskatoon berry. The city is also called the City of Bridges, with seven spans across the South Saskatchewan River. Broadway Bridge links the historic shopping area of Broadway Avenue, the city's oldest shopping district, with downtown.

It's no wonder the cropland around Saskatoon bears bountiful harvests—the area receives more sunshine than almost any other region of Canada. The mining industry also supports the economy, producing more uranium and potash than anywhere else in the world.

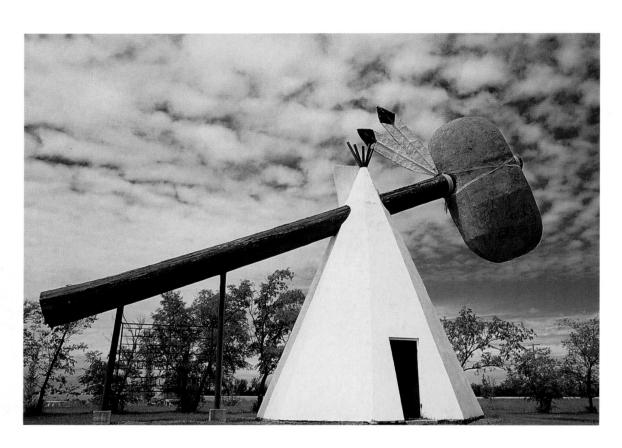

The world's largest tomahawk is on display in the community of Cut Knife. First Nations people once used tomahawks made of bone, stone, or wood. After the arrival of the Europeans, many were made from iron.

In the 1690s, Hudson's Bay Company employee Henry Kelsey was the first European to explore Saskatchewan. Today, much of the province remains sparsely populated, a web of farmland, pristine prairie, boreal forest, and wetlands.

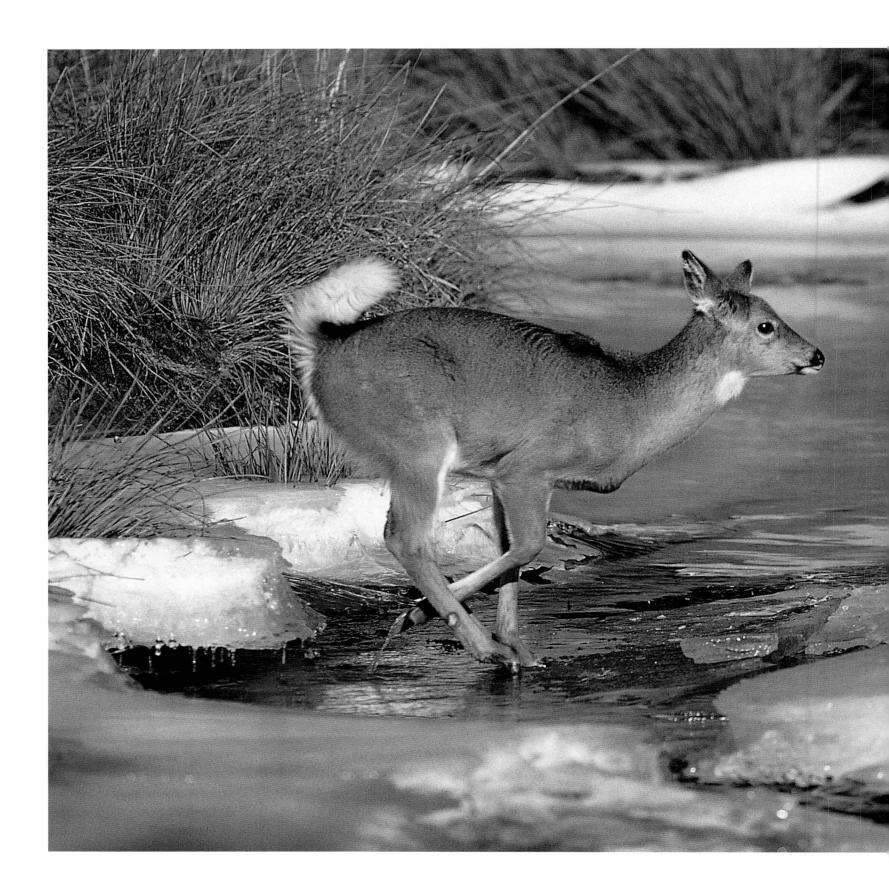

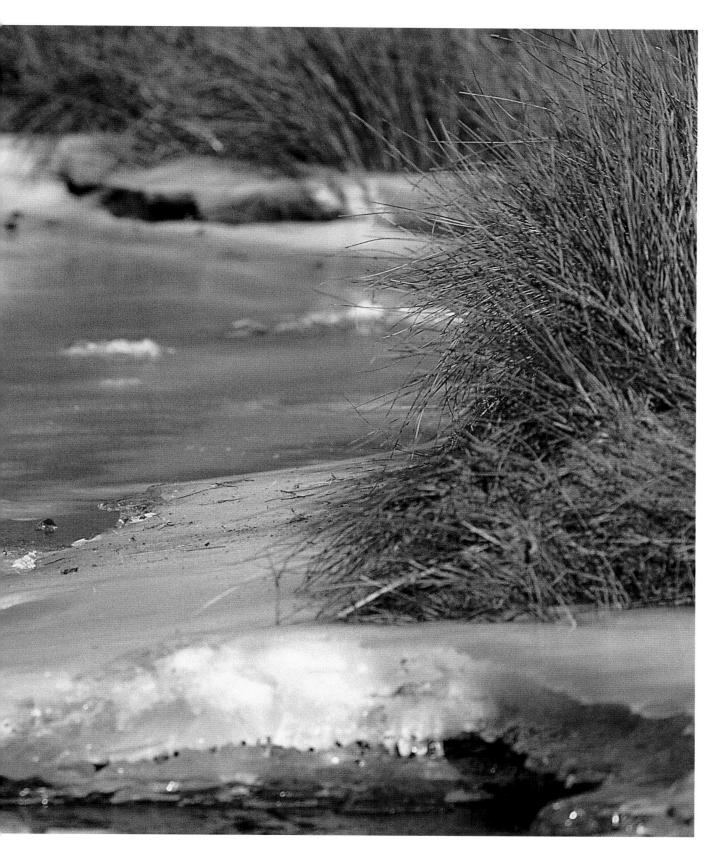

Through brush or in deep snow, whitetail deer establish and follow a system of rough trails. They use these to quickly evade wolves, coyotes, or wild cats.

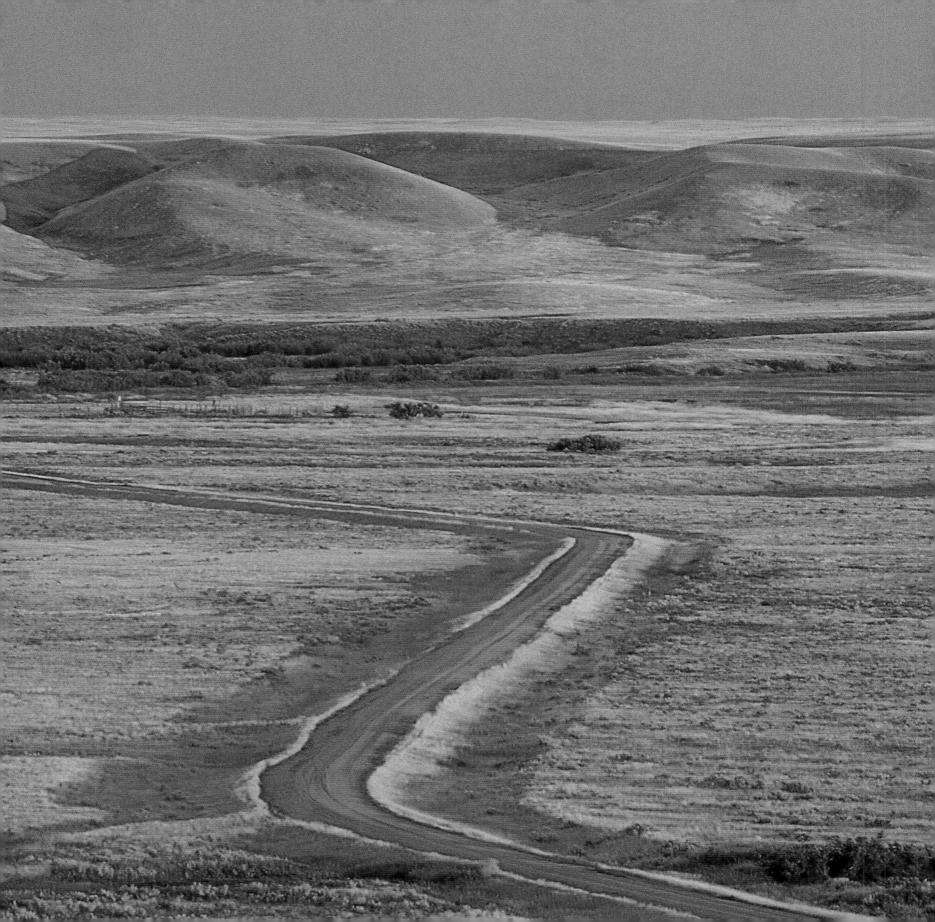

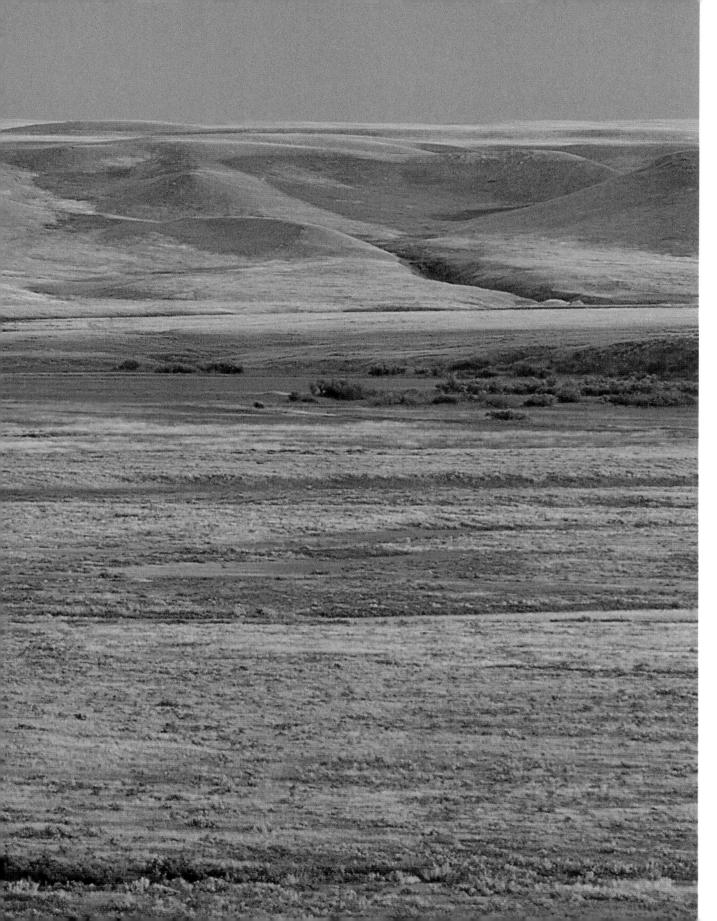

The Canadian government established Grasslands National Park in the late 1980s, in an effort to protect the mixed prairie grasslands. In the past, this land has been used as a hunting ground by First Nations and Métis people, as forage for cattle, and as cropland. Now the government is slowly expanding the preserve, buying privately owned property as it becomes available and adding it to the park.

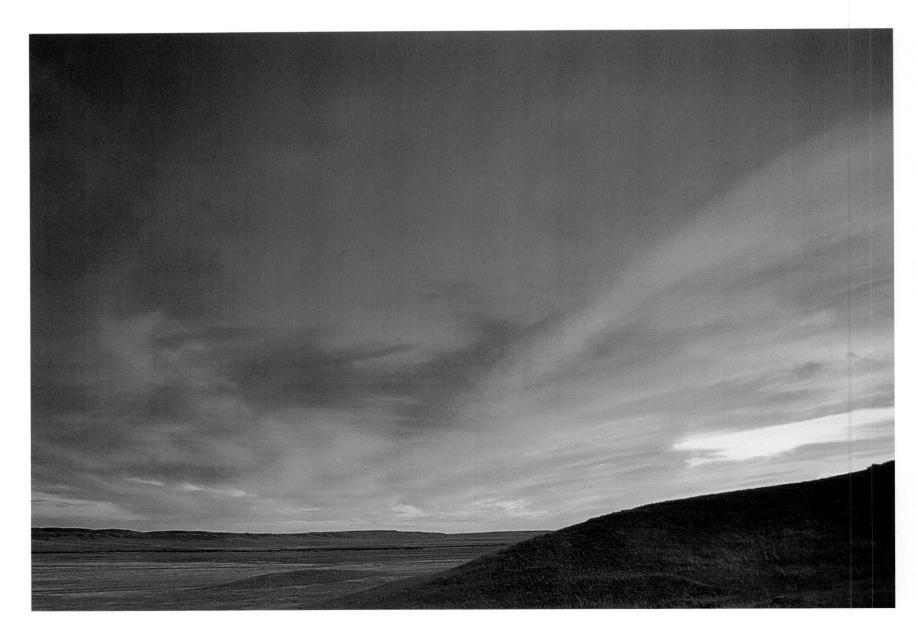

The land protected by Grasslands National Park is the native home of prairie dogs. Pronghorns, grouse, rattlesnakes, hawks, and endangered burrowing owls also make their homes in the prairie grasses.

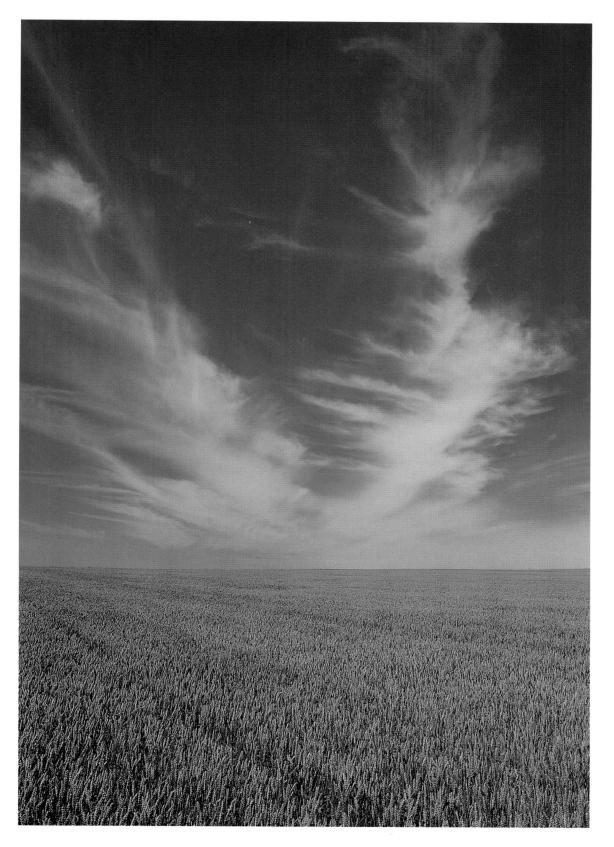

Wheat, the staple of Saskatchewan's economy, is not indigenous to North America. Brought by settlers from Europe, the first wheat was planted in western Canada in 1754 in the Carrot River Valley. Saskatchewan now grows about two billion dollars worth of the crop each year.

Wind rustles through crops near Turtleford in west-central Saskatchewan. When people think about Saskatchewan, they imagine mostly farms and grasslands, but only 37 percent of the province's population lives in rural areas. The rest live in towns and commercial centres such as Regina and Saskatoon.

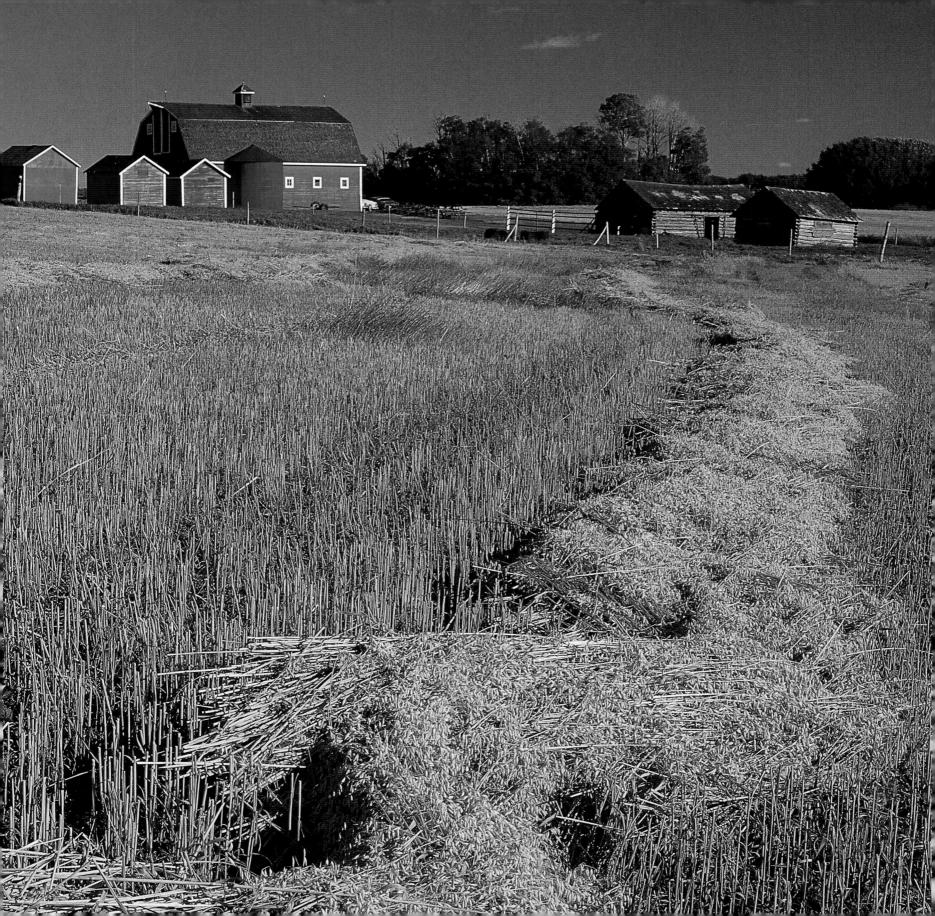

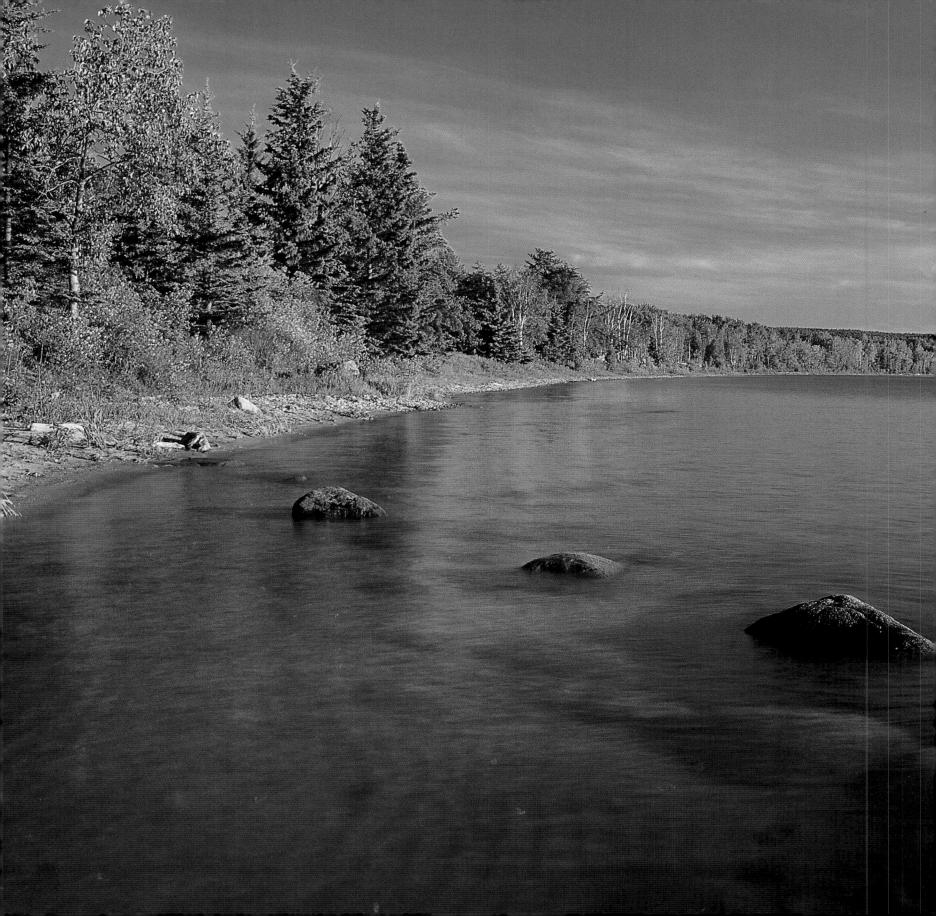

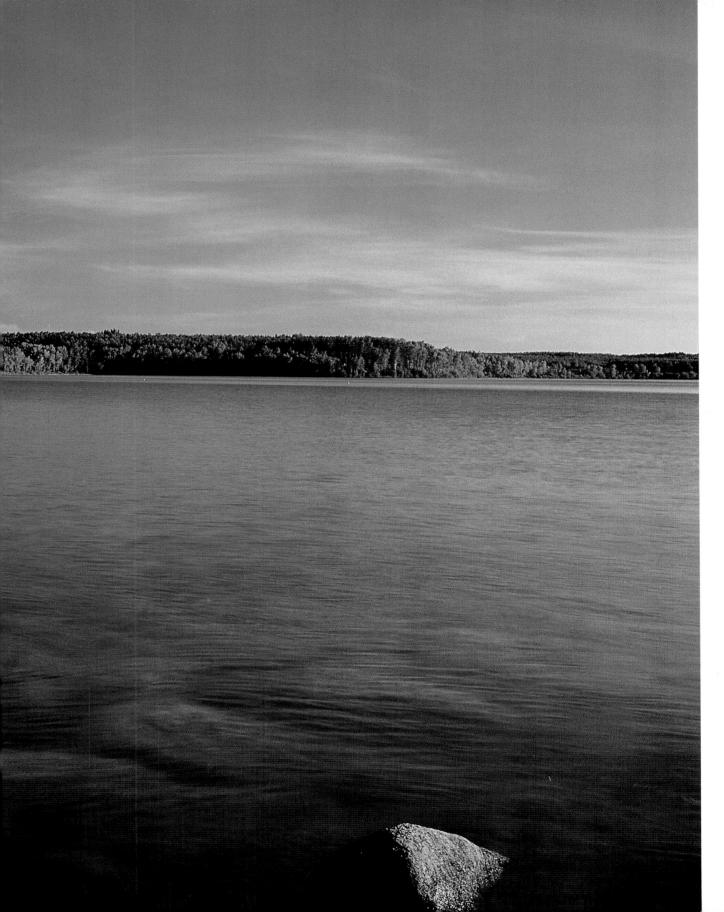

Cold Lake extends across the Alberta-Saskatchewan border. Its eastern shore is protected by Saskatchewan's Meadow Lake Provincial Park, a 1,600-square-kilometre (620-square-mile) reserve encompassing 25 clear lakes, sandy beaches, and the Waterhen River.

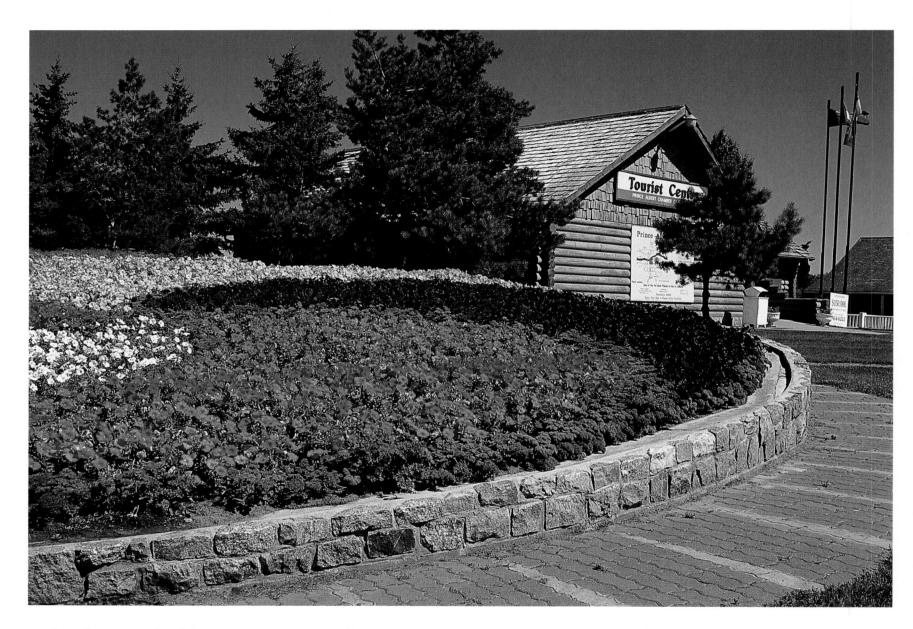

Saskatchewan's third-largest city, Prince Albert, is billed as a Gateway to the North. The city is a commercial centre for the region's mining, forestry, and agriculture industries and a base for visitors exploring Prince Albert National Park.

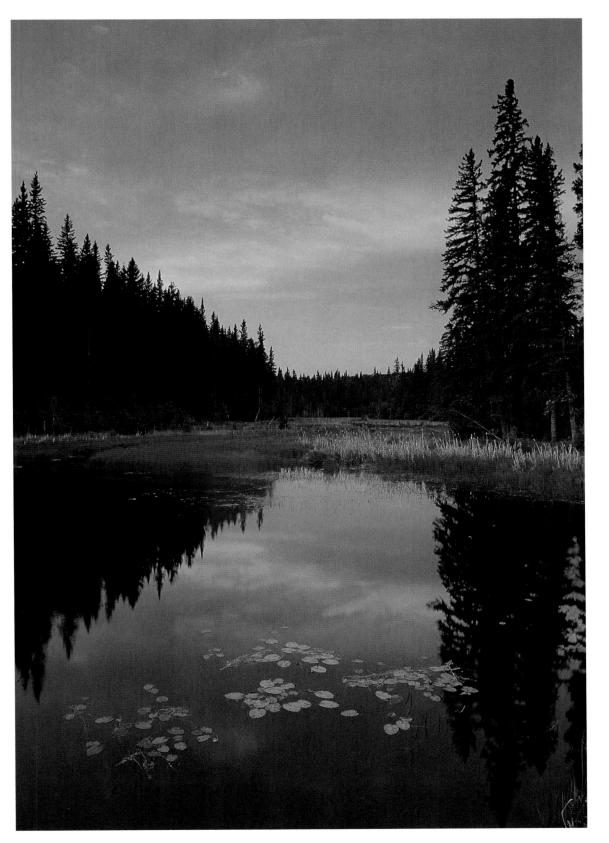

Within the 388,000hectare (959,000acre) Prince Albert National Park, there are about 1,500 lakes and streams. Many of northern Saskatchewan's waterways are known to anglers for their rich yields of northern pike, walleye, and trout. In total, there are more than 68 fish species—and 200 fishing camps—in the province.

The aspen groves of central Saskatchewan gradually give way to thick northern forests in Prince Albert National Park. These woods and the park's many lakes are home to a diversity of wildlife, from wolves and caribou to pelicans and ospreys.

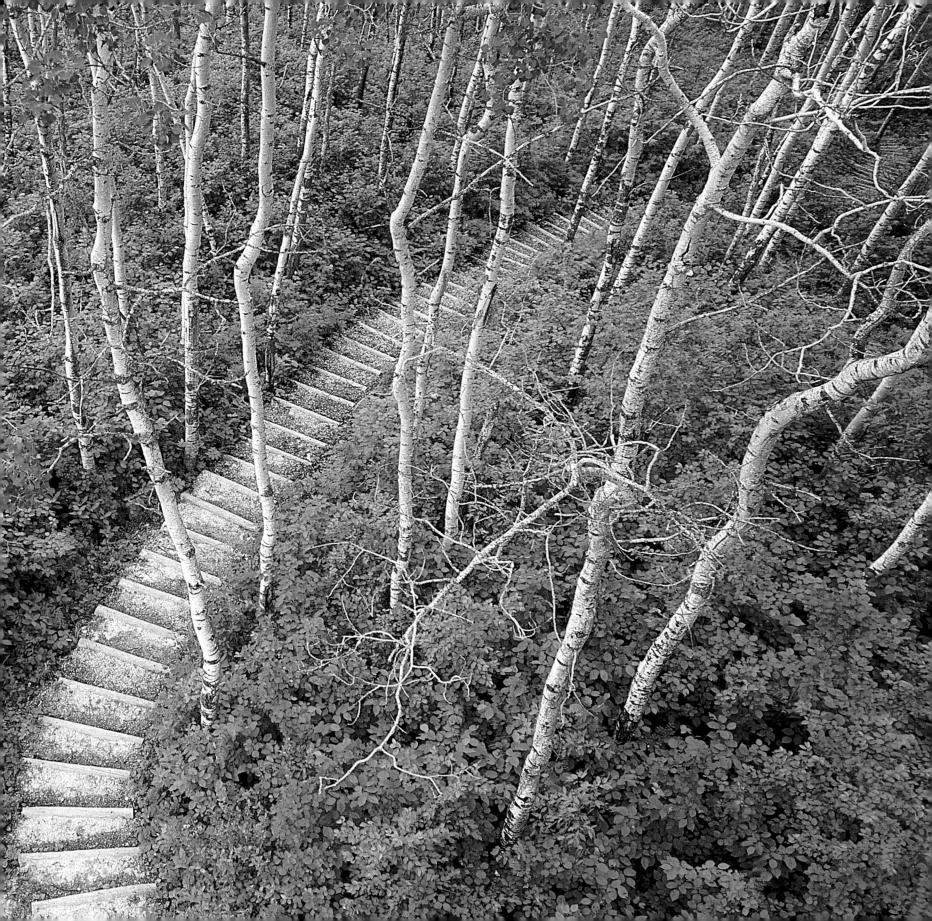

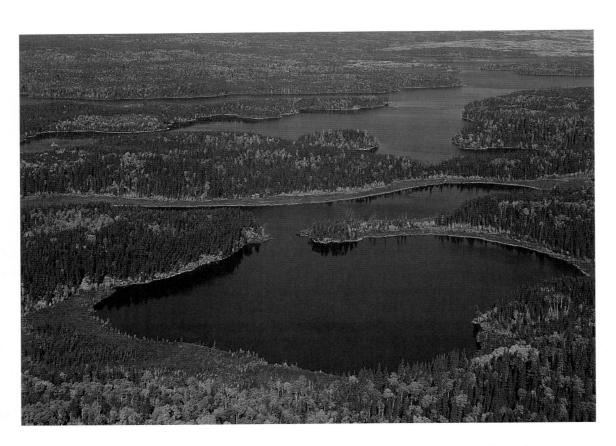

Lac La Ronge, Saskatchewan's largest provincial park, lies within the rugged Canadian Shield. The park protects thousands of islands and hundreds of lakes, some of them travelled by fur traders centuries ago.

Thirty canoe routes lead through the waterways of Lac La Ronge Provincial Park. The area also offers hiking trails, angling, houseboating, and cross-country skiing. There is even a golf course just outside the park's boundaries.

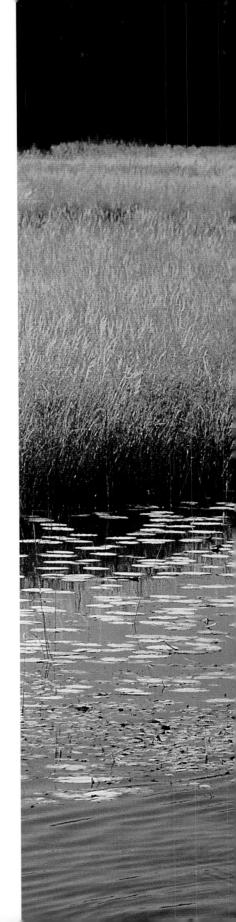

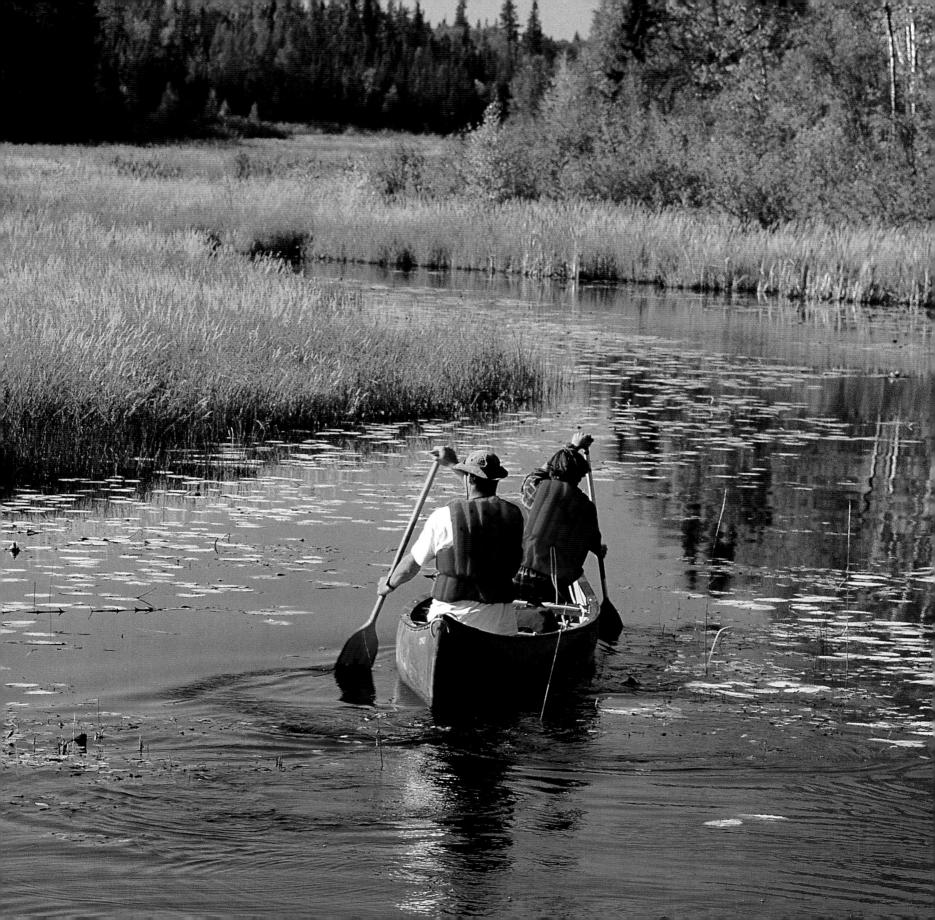

In the 1860s, Fort Carlton was a fur-trading base for the Hudson's Bay Company. Today, a stockade, reconstructed buildings, and a teepee encampment offer visitors a chance to experience life at a time when Canada's wilderness was still being explored.

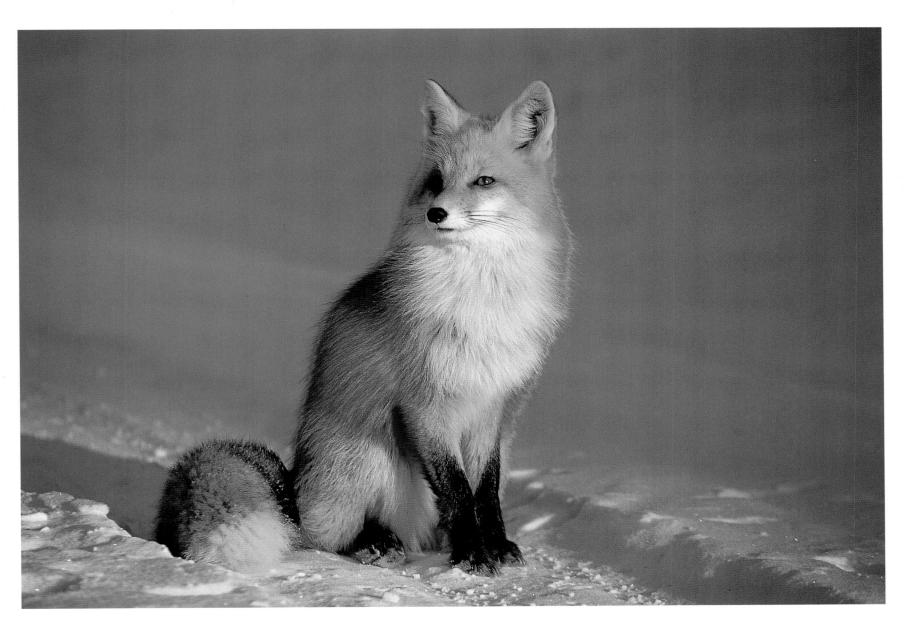

Feeding on rodents, birds, insects, and almost anything else that appears in its path, the red fox is an efficient predator both in isolated forest and on the outskirts of urban areas.

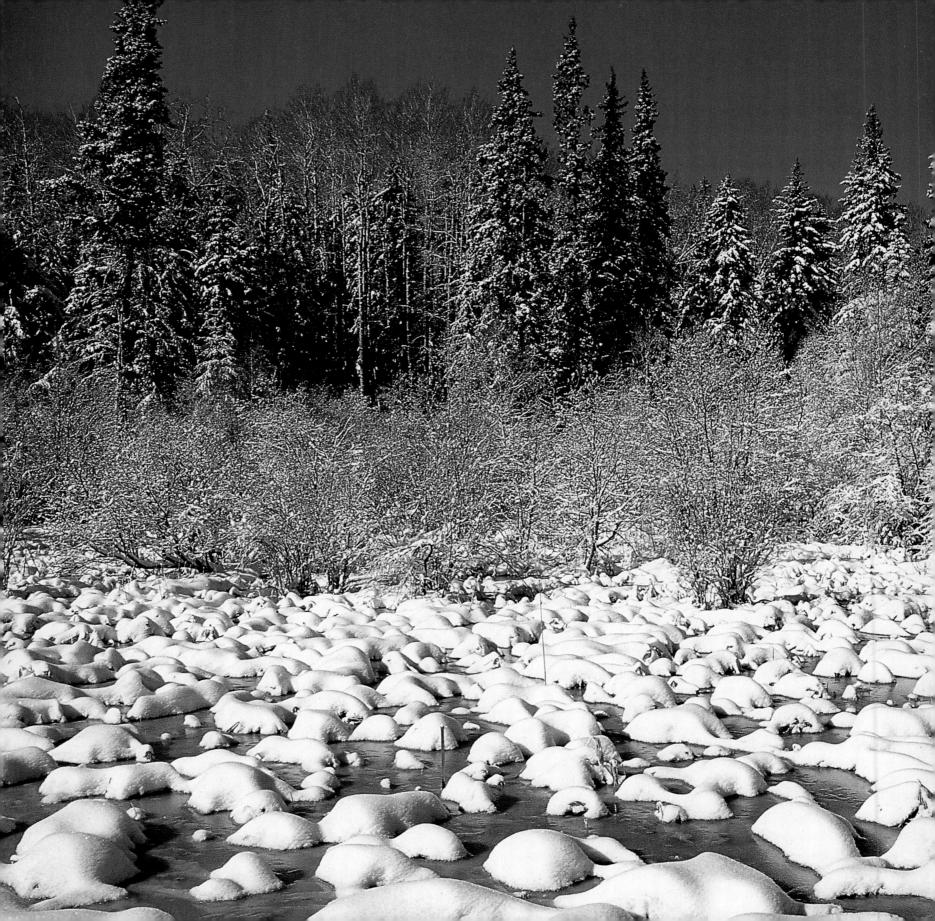

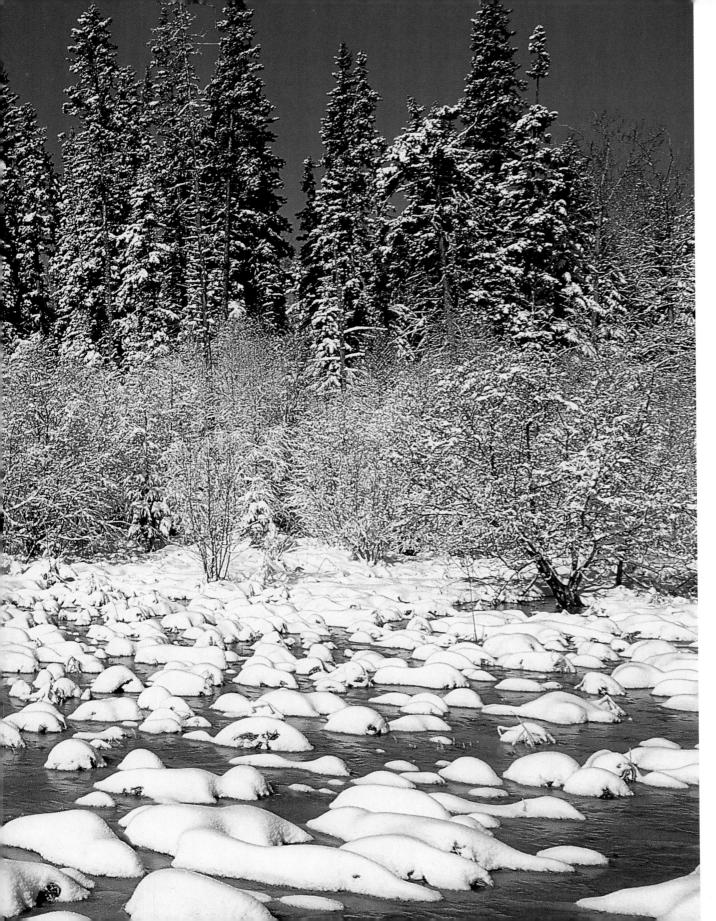

More than half of the province's 651,900 square kilometres (251,600 square miles) is forest. Much of this is boreal, or northern, forest, covering a wide belt of land between the southern grasslands and the arctic plains to the north.

Photo Credits

CRAIG AURNESS/FIRST LIGHT 1, 3, 16–17, 20–21

DARWIN WIGGETT/FIRST LIGHT 6-7, 9, 30-31, 33, 40-41, 46-47, 55, 56-57, 58, 60-61, 64-65, 84-85, 87, 88-89

G. Petersen/First Light 8

D. REEDE/FIRST LIGHT 10-11

Mike Grandmaison 12, 29, 32, 38, 50–51, 52–53, 72–73, 82–83

THOMAS KITCHIN/FIRST LIGHT 13, 24, 39, 70, 76–77

RON WATTS/FIRST LIGHT 14-15, 42

CLARENCE W. NORRIS/LONE PINE PHOTO 18, 23, 36, 59, 67, 68, 69, 71, 75, 86, 90, 91, 92

Alan Sirulnikoff 19, 37, 78–79

ALAN MARSH/FIRST LIGHT 22

ALAN SIRULNIKOFF/FIRST LIGHT 25, 26, 28, 43, 80

Wayne Shiels/Lone Pine Photo 27, 74

ALLEN LEFEBVRE/LONE PINE PHOTO 34-35

KEN STRAITON/FIRST LIGHT 44, 45

WAYNE LYNCH 48, 49, 62, 93, 94-95

BRIAN MILNE/FIRST LIGHT 54

Mark Degner 63

GLEN AND REBECCA GRAMBO/FIRST LIGHT 66

DARWIN WIGGETT 81